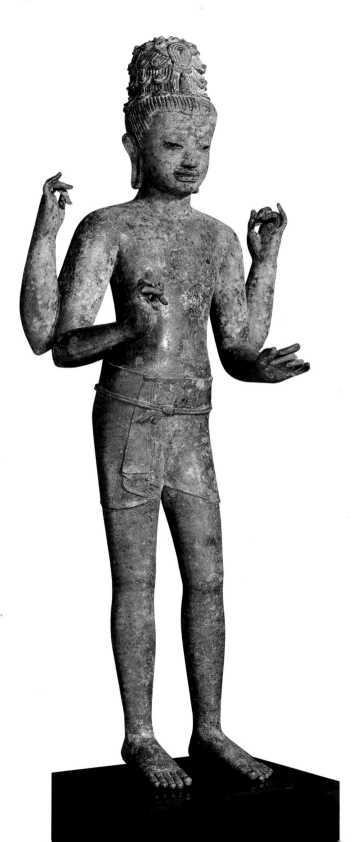

BUDDHA

OF THE FUTURE

BUDDHA
OF THE FUTURE

AN EARLY MAITREYA FROM THAILAND

Nandana Chutiwongs

Denise Patry Leidy

THE ASIA SOCIETY GALLERIES, NEW YORK

Distributed by
THE UNIVERSITY OF WASHINGTON PRESS, SEATTLE

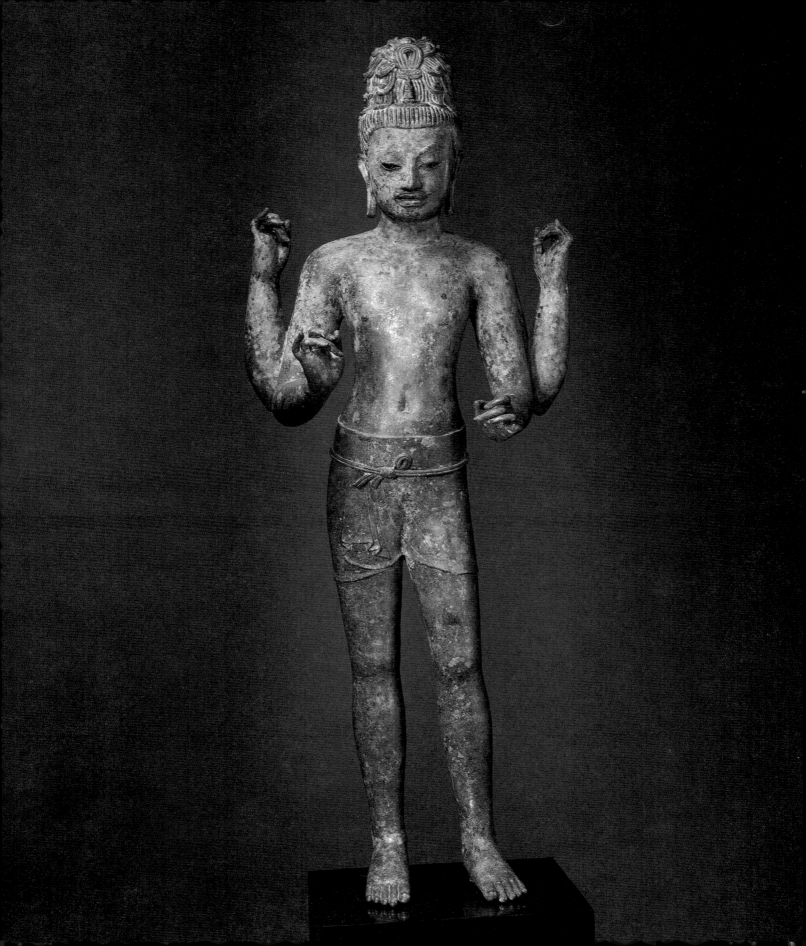

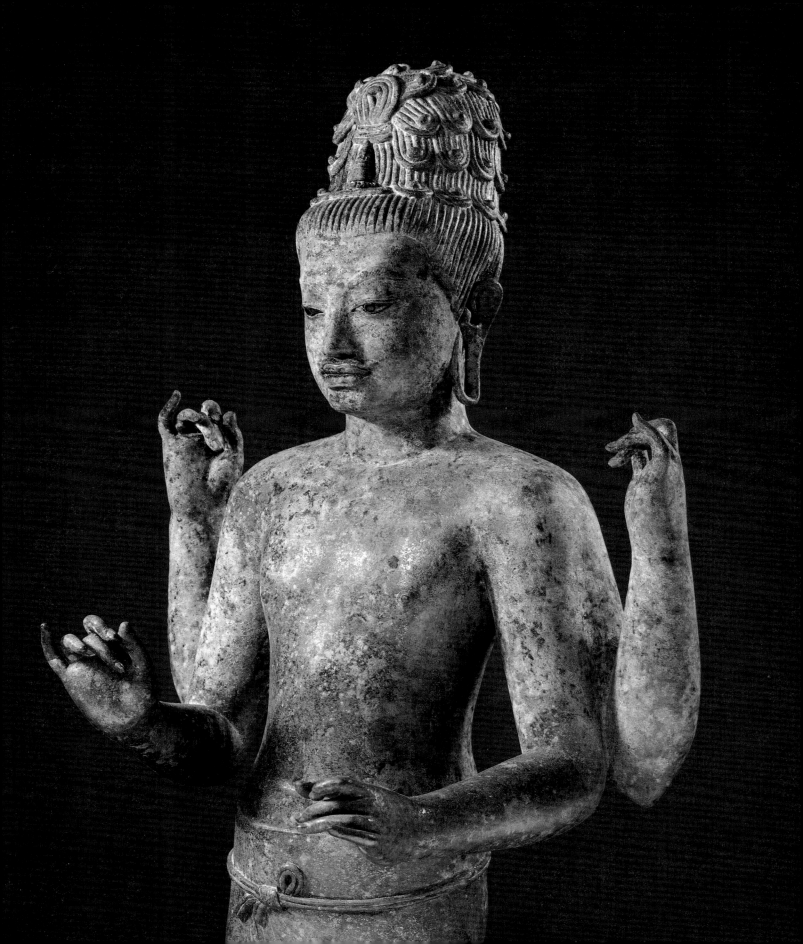

Published on the occasion of
Buddha of the Future: An Early Maitreya from Thailand
an exhibition organized by The Asia Society Galleries,
New York, and curated by Denise Patry Leidy

The Asia Society Galleries, New York
April 13 – July 31, 1994

Kimbell Art Museum, Fort Worth, Texas
September 3 – November 27, 1994

Buddha of the Future: An Early Maitreya from Thailand and related pro-
grams are part of The Asia Society's Thailand Education
Program, which has been made possible through the generous
support of the Royal Thai Government. Additional funding for
the exhibition and catalogue has been provided by the National
Endowment for the Arts, the Armand G. Erpf Fund, the Friends
of The Asia Society Galleries, The Starr Foundation, the Arthur
Ross Foundation, and an anonymous donor.

Cover; pages 1, 4, 5, 8–9

M A I T R E Y A

Thailand, excavated at Prakhon Chai;
8th century
Bronze with inlays of silver and black stone
38 in (96.5 cm)
The Asia Society, The Mr. and Mrs.
John D. Rockefeller 3rd Collection

Note to the Reader
Unless otherwise stated, all images of Maitreya are in his form as
a bodhisattva.
In the text, foreign-language technical terms are given in simplified
forms to more closely approximate their pronunciations.
Only the height of statues is given.
Numbers in brackets, such as [34], refer to illustration numbers.

Published by
The Asia Society Galleries, New York
725 Park Avenue
New York, New York 10021-5088
in association with
Sun Tree Publishing, Ltd.
Block 205 Henderson Road
No. 03-01 Henderson Industrial Park
Singapore 0315
distributed in North America by
University of Washington Press
P.O. Box 50096
Seattle, Washington 98145-5096

LC: 94-070506

ISBN: 0-87848-078-1 (The Asia Society Galleries)
ISBN: 981-00-5430-0 (Sun Tree Publishing)
ISBN: 0-295-97368-4 (University of Washington Press)

Publication Manager: Joseph N. Newland
Publication Associate: Merantine Hens-Nolan
Production Assistant: Alexandra Johnson
Editor: Vajra Kilgour
Map: Irmgard Lochner
Design and Composition in Centaur: Dan Miller Design, NY
Printed and bound by Nissha Printing Co., Ltd., Kyoto, Japan

CONTENTS

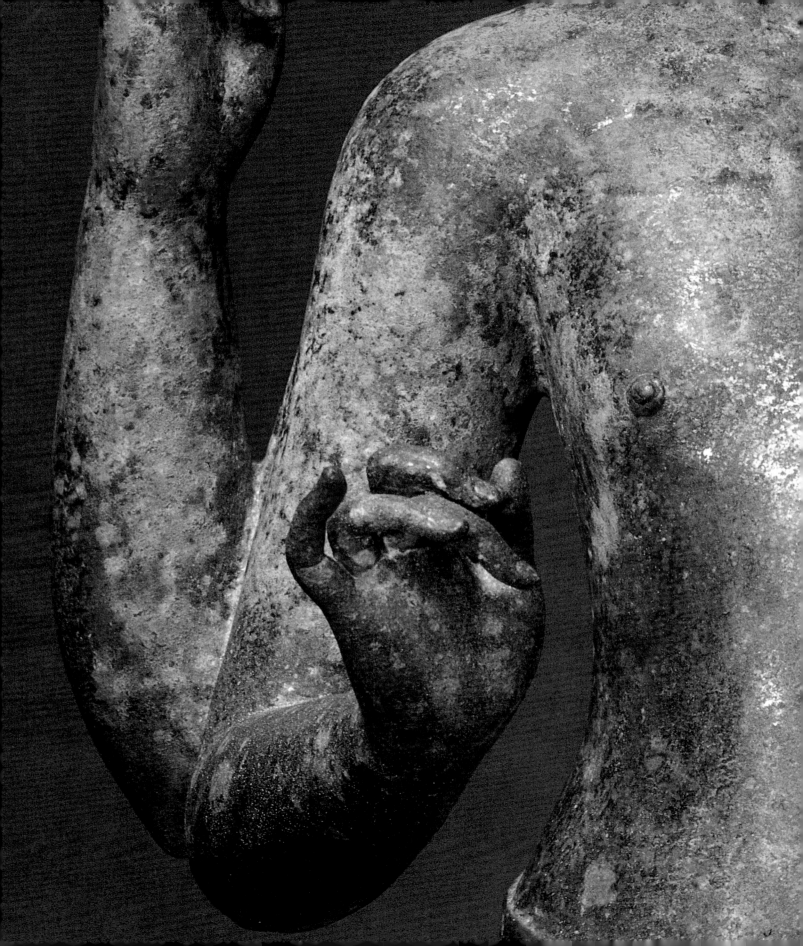

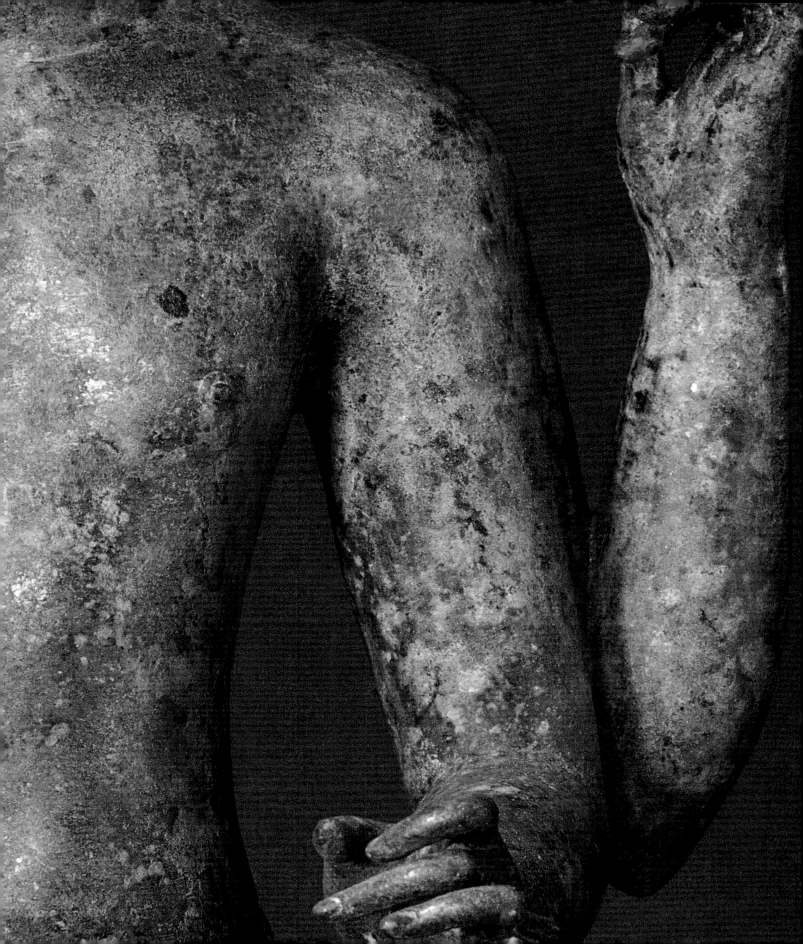

FOREWORD

One of the finest sculptures in The Asia Society's Mr. and Mrs. John D. Rockefeller 3rd Collection is an elegant image of Maitreya, a Buddhist deity destined to become the Buddha of the future age. Discovered near Prakhon Chai in northern Thailand and dating from around the eighth century, this sculpture and the sizable group of bronzes found with it raise important questions regarding the development of early Southeast Asian Buddhist art. Although information about that period of Southeast Asian history is scant, the abundant visual evidence of superb sixth- to ninth-century stone and bronze sculptures from the region attests to remarkable artistic developments and a complex pattern of cultural exchange in Southeast Asia. *Buddha of the Future: An Early Maitreya from Thailand* addresses some of the attendant issues by focusing on the Galleries' Maitreya and selected Prakhon Chai images and by highlighting their relationship to sculptures from neighboring artistic centers.

This exhibition is the third in The Asia Society Galleries' Objects in Context series. These modestly scaled exhibitions are developed around a single work of art, generally selected from The Asia Society's Rockefeller Collection. Other objects are brought together to illuminate issues that are raised by the centerpiece, and the exhibitions are organized thematically according to gradually expanding circles of questions and knowledge. This is done in the firm belief that exhibitions of an intimate size and specific focus can be effective in educating museum visitors about important issues in Asian art while encouraging them to look carefully and savor the pleasure of viewing superb works of art.

Buddha of the Future brings together a remarkable group of early Southeast Asian sculptures from public and private collections, many of which have never before been shown publicly or in the United States. We are particularly grateful to the Government of Thailand and to the staff of the Fine Arts Department of the National Museum, Bangkok, for their cooperation in arranging the loans of a number of preeminent objects from Thailand.

This project is part of a multiyear initiative of The Asia Society to educate Americans about Thailand and its special position in the region of Southeast Asia. This endeavor was warmly endorsed by Ambassador H. E. Nitya Pibulsonggram, the Permanent Representative of the Permanent Mission of Thailand to the United Nations and an enthusiastic supporter of the Society's activities. Through his assistance, we were able to secure funding from the Government of Thailand to help defray some of the costs of the exhibition and catalogue. Additional support was provided by the National Endowment for the Arts, the Armand G. Erpf Fund, and an anonymous donor. The continuing support for the Galleries' exhibition program by the Friends of The Asia Society Galleries, The C. V. Starr Foundation, and the Arthur Ross Foundation is also gratefully acknowledged.

One of the challenges of organizing this exhibition was the relative dearth of scholarly material on the subject, and I would like to join exhibition curator Denise Patry Leidy in thanking those who gave advice as she and I developed the exhibition concept. I should also like to thank the members of The Asia Society Galleries' advisory committee for encouraging us to continue to mount these small exhibitions built around the permanent collection. We are grateful to Nandana Chutiwongs, whose doctoral research focused on this material, for her thoughtful essay outlining the maze of artistic interrelationships

and patterns of stylistic developments in early Southeast Asian Buddhist art. Dr. Leidy's own essay on Maitreya iconography also promises to provide new scholarly insights in Buddhist studies in general and Southeast Asian Buddhist art in particular.

When the Prakhon Chai bronzes first came to light in the 1960s, many entered public and private collections, primarily in the United States. This is the first time that a number of them have been shown together. We would like to thank our colleagues in the lending museums and those generous individual collectors who have agreed to part with their treasures temporarily for the benefit of art historians and the broader public. Their generosity will be appreciated by everyone who visits the exhibition.

We are delighted that Edmund P. Pillsbury, director of the Kimbell Art Museum, saw the value of this exhibition and adjusted the museum's schedule to accommodate *Buddha of the Future*. The visitors to the exhibition in Fort Worth will, no doubt, be pleased to see the Kimbell Museum's own Maitreya in this context.

Buddha of the Future is the fourth consecutive exhibition in one year to be organized and presented by The Asia Society Galleries' very small and very dedicated staff, and I should like to add my thanks to those in Dr. Leidy's Acknowledgments.

It is by careful design that *Buddha of the Future: An Early Maitreya from Thailand* is being shown at The Asia Society at the same time as *Asia/America: Identities in Contemporary Asian American Art*. They both present examples of the dynamic cultural exchanges that occur within Asia and between Asia and other parts of the world. The juxtaposition makes it clear that The Asia Society has every intention of presenting classically beautiful, traditional objects in new contexts at the same time that it endeavors to define the contemporary Asian experience in a new way. We hope that those who come to view one exhibition will pause to view the other and appreciate the aesthetic and cultural complexity of Asia, past and present.

Vishakha N. Desai
Director of the Galleries
Vice President for Program Coordination
The Asia Society

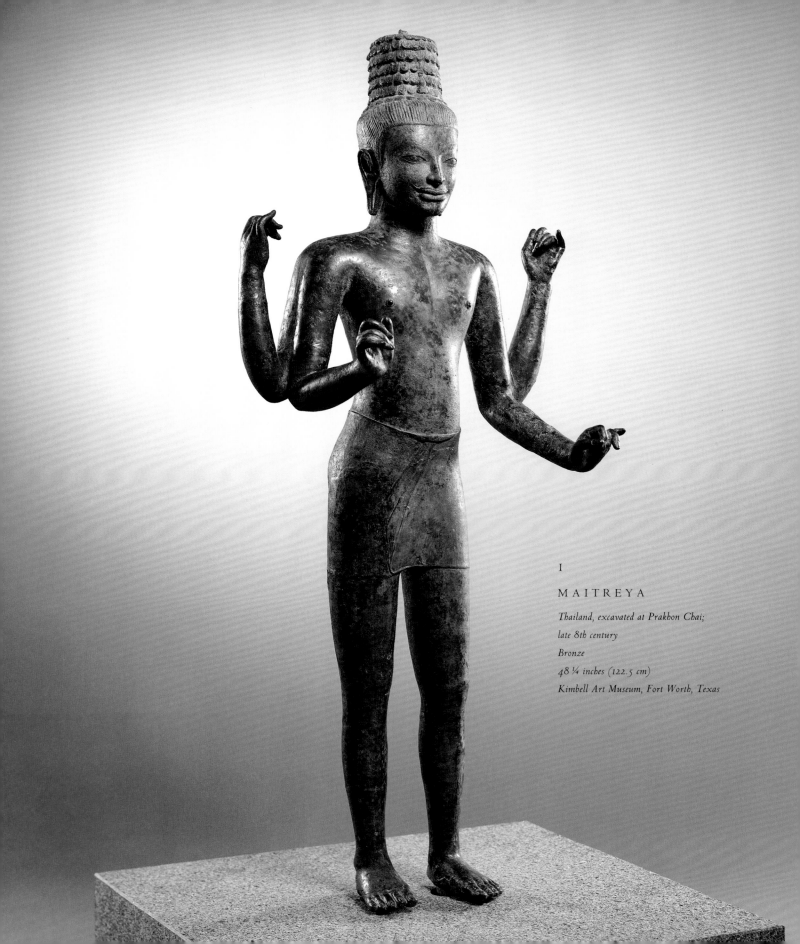

I

MAITREYA

Thailand, excavated at Prakhon Chai;
late 8th century
Bronze
48 ¼ inches (122.5 cm)
Kimbell Art Museum, Fort Worth, Texas

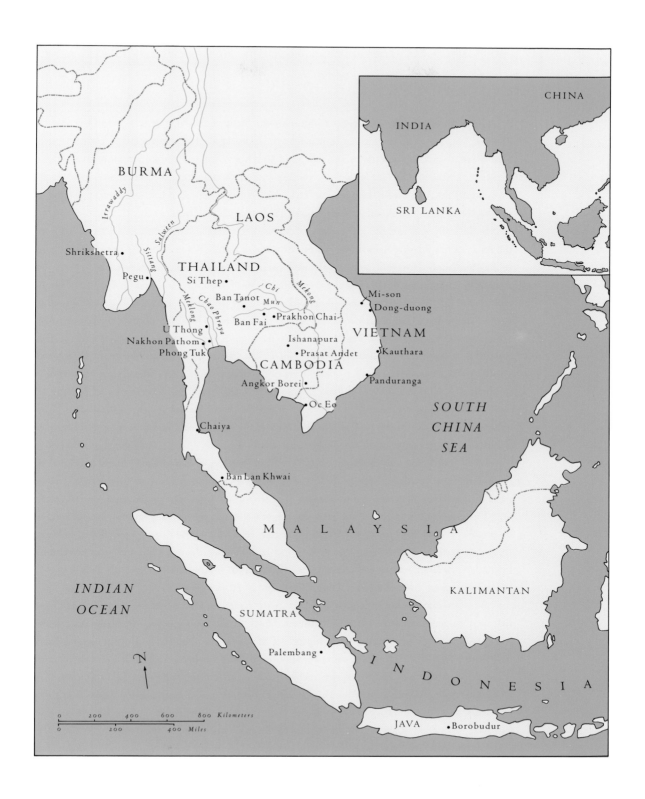

CHINA

INDIA

SRI LANKA

BURMA

Irrawaddy

Salween

LAOS

Shrikshetra •

THAILAND

Pegu •

Sittang

Si Thep •

Chi

Mekong

Ban Tanot

Mun

Mi-son

Dong-duong

Meklong

Chao Phraya

Ban Fai

• Prakhon Chai

U Thong •

Ishanapura

VIETNAM

Nakhon Pathom •

Phong Tuk •

• Prasat Andet

• Kauthara

CAMBODIA

Angkor Borei •

• Panduranga

• Oc Eo

SOUTH
CHINA
SEA

Chaiya •

Ban Lan Khwai •

M A L A Y S I A

KALIMANTAN

INDIAN
OCEAN

SUMATRA

N

Palembang •

I N D O N E S I A

```
0      200    400    600    800  Kilometers
0          200          400  Miles
```

JAVA • Borobudur

PREFACE

A magnificent eighth-century bronze sculpture is the focus of *Buddha of the Future: An Early Maitreya from Thailand*. This sculpture is widely acknowledged to be one of the finest of the pieces excavated from the base of an abandoned temple in the village of Prakhon Chai in Buriram Province in north central Thailand. Uncovered in 1964, this cache remains one of the most spectacular archeological discoveries from Southeast Asia, and it continues to raise challenging questions regarding the stylistic and iconographic development of Buddhist sculpture in Thailand and Cambodia.

Stylistically, particularly in the shape of his facial features and in the proportions of his physique, the Asia Society Maitreya resembles sculptures made in Cambodia prior to the rise of its great Khmer civilization (ninth–fifteenth century), the builders of such magnificent monuments as Angkor Wat. As a result, this piece and other sculptures excavated from or attributed to Prakhon Chai have often been classified as "pre-Angkor," an amorphous and somewhat problematic term that is generally used to categorize art made in Cambodia before the rule of the Khmers. The application of the term to works of art excavated in north central Thailand helps to distinguish the Prakhon Chai–style material from art produced in northwest Thailand under the rule of the Dvaravati kingdom, primarily dating from the seventh to ninth centuries, or that made in the Shrivijayan style at approximately the same time in the southern or peninsular part of Thailand that was controlled by the Shrivijiya empire of Indonesia. Such a use of the art-historical term "pre-Angkor," a term with no relation to present-day political boundaries, exemplifies one of the problems in the study of Southeast Asian Buddhist sculpture caused by the coexistence in one region of diverse peoples, constantly changing alliances, and shifting boundaries.

In this exhibition and catalogue, sculptures from Prakhon Chai and works found at related sites in or near Buriram Province, such as Ban Fai and Ban Tanot, are compared with sculptures from other parts of Thailand, Vietnam, and Cambodia in order to give some idea of the sheer variety of art produced in mainland Southeast Asia from the seventh through the ninth centuries. In addition, related objects from India, Sri Lanka, and Indonesia introduce several of the distinctive Buddhist cultures that flourished in those areas during the same period and illustrate their cultural and artistic relationships. Finally, the development of complex imagery of Maitreya, as a bodhisattva and as a Buddha, is shown, using images from India, Kashmir, Tibet, Nepal, and Southeast Asia.

As is always the case with such a project, many hands, heads, and hearts contributed. Thanks go first to our colleagues at the National Museum, Bangkok, for lending several very important sculptures to the exhibition. The addition of a sculpture of Maitreya from Ban Fai and of the famous head of a bodhisattva from Ban Tanot add immeasurably by showing further examples of the style of northeast Thailand. I would also like to express my gratitude to all of the lenders to the exhibition, many of whom not only generously parted with well-loved objects but also shared their insights into them and the issues they illustrate. Particular thanks are due to Robert Ellsworth for sharing his memories of the discovery of Prakhon Chai and its importance to the study of Southeast Asian art.

A number of scholars have been helpful in advising us on the scope of the project and the scholarship on particular works of art. We are especially indebted to Nandana Chutiwongs for contributing the

first essay to the catalogue. In it she presents a masterly survey of the variety of regional styles found in early Southeast Asian art and the complex interrelationships between them. She and Hiram H. Woodward, Jr., of the Walters Art Gallery, are to be thanked for their cogent suggestions regarding the development of the object list and the articulation of the themes in the exhibition. I am also grateful to Woody for his useful comments on my essay. Stanley O'Connor of Cornell University and Forrest McGill also gave valuable advice.

The elegant design of the exhibition in New York is by Sanders Design Works, Inc. This handsome book was designed by Dan Miller Design, New York. The map was made by Irmgard Lochner.

Ultimately, the greatest share of the credit for this exhibition, tour, and catalogue is due to my colleagues at The Asia Society Galleries. Director Vishakha N. Desai, who developed the Object in Context series, remains a continuing source of good advice and insights. Publications manager Joseph N. Newland's strict guidelines and conceptual insights, and his work with Vajra Kilgour on the editing of the text, did much to improve the quality of the catalogue. Joseph, with the able assistance of Merantine Hens-Nolan, galleries associate, and Alexandra Johnson, is responsible for the production of this book. Registrar Amy V. McEwen's work on the many logistical details of the loans and tour was, as always, an invaluable contribution to the completion of the project. Both Amy and I are indebted to Richard A. Pegg, curatorial associate, for his help in all phases of this project and for his careful work in supervising the installation of the objects. The customary perfectionism of Merantine Hens-Nolan is reflected in her coordination of the exhibition graphics. Thanks are due also to Chana Motobu, now a student at the University of Hawaii, for her help in gathering materials during the early phases of this project while she worked as an intern at the Galleries under the sponsorship of the National Endowment for the Arts. Nancy Blume, tour coordinator, deserves thanks for developing education programs around the exhibition; and Nancy and our docents are due special gratitude for their exceptional work in making this material available and interesting to many diverse audiences. Nicolas G. Schidlovsky's and Karen L. Haight's work in fundraising; Heather Steliga Chen's development of a publicity campaign; and the programming efforts of Rhoda Grauer, Linden E. Chubin, Anne Kirkup, and Rachel Cooper of the Media, Performances and Lectures Department contributed in many ways to the success of this project. Finally, I owe a special debt of gratitude to Mirza Burgos, Nicole Hsu, and Alexandra Johnson, whose exceptional contributions to the running of all aspects of the Galleries help make projects such as this one possible.

Denise Patry Leidy
Curator
The Asia Society Galleries

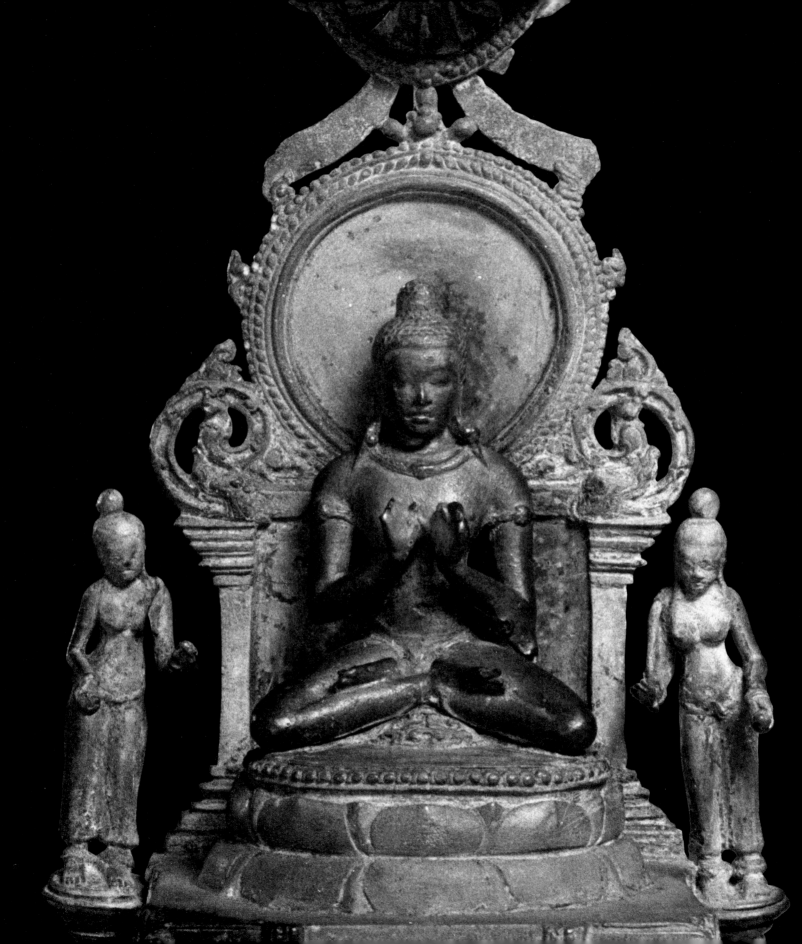

SOUTHEAST ASIAN BUDDHIST SCULPTURES FROM THE SEVENTH TO THE NINTH CENTURIES

Nandana Chutiwongs

Buddhism became one of the most prominent faiths in India during the third century B.C.E. under the patronage of Emperor Ashoka of the Maurya dynasty. According to both his own inscriptions and the chronicles of later times, this powerful monarch sent missionaries abroad to propagate the doctrine of the Buddha beyond the boundaries of his own realm. Local traditions in many parts of Asia attribute the inception of their Buddhist culture to the activities of Ashoka, but there is no material evidence to support such a claim; the only exception may be Sri Lanka, whose earliest Buddhist inscriptions date from about the second or first century B.C.E. and are written in a script derived from the type used in the domain of the Maurya emperor.

Southeast Asia has so far produced no material traces of this alleged early cultural contact with India, although it had evidently maintained commercial relations with the Indian subcontinent since prehistoric times. Since the two regions were geographically

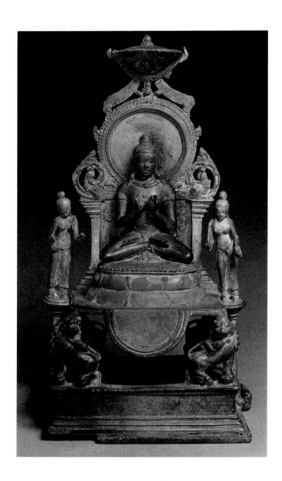

above and page 16 (detail)

2

VAIROCANA WITH
ATTENDANTS

Thailand; late 8th century
Bronze
8 in (20.0 cm)
National Museum, Bangkok

separated from one another by the wild mountains and dangerous swamps of Assam, communications by sea played an important role. Trading activities between the two regions, nevertheless, would have been quite sporadic up to the beginning of the Common Era, when there was an increasing demand in Rome in the West and China in the Far East for exotic goods. India, Sri Lanka, and Southeast Asia then became part of a prosperous trading network that stretched across half the world, from the Roman Empire to imperial China. Important commercial centers actively involved in the Roman trade flourished on the coasts of India and Sri Lanka, and extended their activities towards the West and the East.[1] Mercantile objects from the Mediterranean world, the Indian subcontinent, and China have been found at ancient ports on the coasts of Southeast Asia, from Burma and Thailand down to the Malay Peninsula and the Indonesian islands, and farther east in Cambodia and Vietnam.[2] These are eloquent testimony to Southeast Asia's involvement in the international trade of the time. Some of these ancient ports, such as Oc Eo in present-day Vietnam and Khlong Thom in peninsular Thailand, besides being entrepôts and partners in trade, were also active manufacturing centers of trading objects that were in demand in other parts of the world.[3]

Commercial settlements grew up along the international trade routes, and grew rapidly into centers of political power and culture by the middle of the first millennium C.E.[4] Trading ships from the Indian subcontinent carried not only merchants and merchandise but also monks and brahmins who introduced the higher aspects of Indian culture, the benefits of which were readily realized by the elites of the regions overseas. Indian religions, statecraft, script, and literature, along with the concept of divine kingship and the mythologies that glorify the gods and rulers, found their way into the court circles of Southeast Asia. The internal structure of many societies underwent a great change, while literate and urban civilizations began to develop in various regions enriched by trade. Organized states and kingdoms ruled by Indian-style kingships rose up in the course of time.

Recent historical research on the formative stages and early

urbanization of Southeast Asia challenges the plausibility of the widely accepted theory that speaks of the existence of large, centralized kingdoms prior to the ninth century. Modern historians are united in presenting a sketch of small states or principalities that coexisted in varying degrees of interdependency while political preeminence kept moving from one center to another.[5] And yet it remains undeniable that there were at times some outstanding states or centers that exercised considerable and long-term influence upon others. On the present archeological and art-historical evidence, the communities of early Southeast Asia may be grouped into a number of cultural complexes, with the most powerful among them acting as regional foci. In spite of the continuing changes in their political relationships, a certain cultural unity did prevail in many areas. Artistic products of Southeast Asia can be classified and grouped, according to their essential features, into a number of regional styles.

Each style grew up as a result of the synthesis and interaction between imported Indian elements and local ideas. China—another great civilization near Southeast Asia—played a relatively insignificant role in this area. Its relations with Southeast Asia had always been predominantly commercial and political in nature, and Chinese cultural and artistic influences are barely discernible in early Southeast Asia, despite the many centuries of diplomatic connections known from historical records.[6]

Cultural influence and artistic inspiration came from the Indian subcontinent in successive waves, varying over time and in provenance, and through various types of agencies. Buddhism and Hinduism, which had become the religions of many Southeast Asian kings, brought with them their traditional architecture and imagery, and Indian artistic modes became the accepted medium for spontaneous expressions of faith and for gaining the favor of the divine. Brahmins, monk missionaries, and, later on, pilgrims traveling along the trade routes obviously played the most important roles in the transmission of Indian art styles and art forms to local communities. Learned Indian ecclesiastics, as a rule, were competent in directing the construction of temples and supervising the making of icons essential to their teaching and ritual. Chinese accounts tell of many monks and brahmins from the Indian subcontinent who erected temples or images, obviously in their own native styles, in the countries to which they had come.[7] Many Indian monks and brahmins are known to have held high office at Southeast Asian courts. Inscriptions from Cambodia and Java contain records of the leading roles that the Indian ecclesiastics played in the founding and consecration of royal temples.[8]

Pilgrims traveling to holy places and important centers of learning in India and Sri Lanka evidently brought home not only mental impressions of religious architecture, sculpture, and painting but also tangible souvenirs in the form of manuscripts, sketches of famous images and shrines, portable icons, and ex-votos collected at various sites.

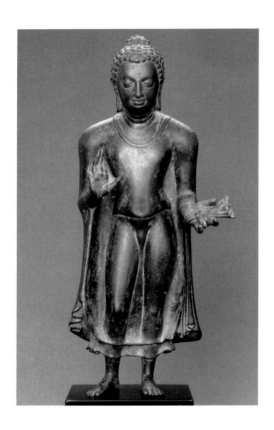

3

SHAKYAMUNI

India; late 6th century
Bronze
19 ⅜ in (49.2 cm)
The Asia Society,
The Mr. and Mrs. John D. Rockefeller 3rd Collection

opposite

4

BUDDHA

Sri Lanka; 8th century
Bronze
6 in (15.2 cm)
D. A. Latchford collection

Sacred texts from India and Sri Lanka were much coveted by pilgrims and envoys on religious missions, and treatises dealing with sacred architecture, images, and rituals were surely among the uncountable bundles of literature carried home by these travelers. Besides such objects of religious significance, portable works of art and luxury wares were also transported along the trade routes, and constituted a large percentage of the merchandise in demand in rich settlements and prosperous kingdoms.

Professional artists are also known to have traveled. Craftsmen who were well versed in traditional Buddhist and Hindu art forms were in great demand at Southeast Asian courts, where art was conceived of not as an aesthetic luxury but rather as a demonstration and assertion of power and as the means to obtain the support of the spiritual or the divine. Instances are recorded of distinguished craftsmen from the Indian subcontinent setting up workshops under royal patronage and training local artisans to work in the new traditions.

Among the artistic influences from abroad, there appears to be a strong impact of the southeast Indian Andhra tradition (about the first century B.C.E. to the third century C.E.) and of its prolongation in that part of India and in Sri Lanka (about the fourth to the eighth centuries C.E.; see [4]). Stylistic elements of the classical Gupta tradition (about the fourth to the sixth centuries; see [3]) are also discernible in practically every region of Southeast Asia, indicating either a direct contact with northern India or an indirect transmission through later Indian styles that retained much of the high ideals of the Gupta age. Influences of the late Gupta/Vakataka style of Maharashtra and of the post-Gupta styles of the Chalukyas and the Rashtrakutas in Maharashtra and southwest India, side by side with those of the Pallavas in the southeast, were particularly strong during the sixth to the eighth centuries. Contributions of Sri Lanka of the late Anuradhapura period (about the seventh to the ninth centuries) are also discernible. Last but not least came the inflow of artistic elements generally known collectively as "Pala style," from the medieval schools of Bihar and Bengal in northeast India that specialized in Buddhist art and metal sculptures [5, 41]. These artistic influences

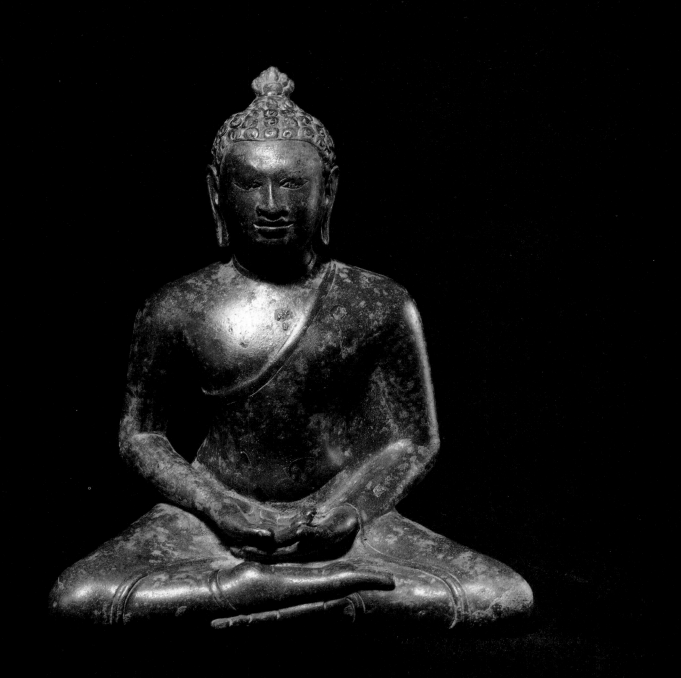

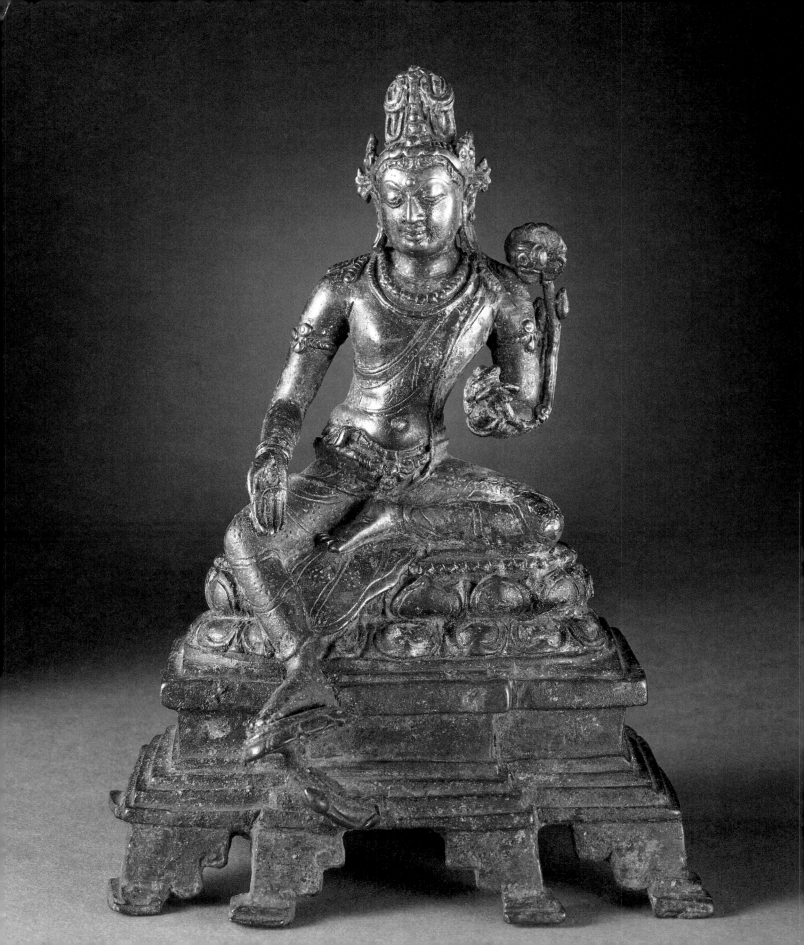

reached Southeast Asia at different times and in varying degrees of intensity. The local response to each wave of influence also varied from place to place, and each locality eventually evolved its own style, in which different types of foreign elements were combined in varying proportions.

Many art styles based on local interpretations of the religious and artistic traditions of India and Sri Lanka grew up in Southeast Asia. The imported religions and the art they inspired became localized and gradually assumed a new form. Each stream of influence from abroad brought its own specific elements, which underwent a process of adaptation, adjustment, and reinterpretation by the local genius of each new area. Artisans, working for the new religions and depicting unfamiliar themes, first imitated the imported styles but gradually modified these according to local taste and requirements. There are indications of shared concepts and many points of similarity in the initial phase of all Southeast Asian art styles, which are clear reflections of their common Indian heritage. Nevertheless, there was nothing like a uniform process of adaptation among the considerable range of environments and ethnic types in Southeast Asia. Each style had its own history, course of development, and characteristic traits, and yet remained to a certain degree susceptible to new waves of influence from the Indian subcontinent, as well as from neighboring regions. Each appears to have developed and flourished in a clearly specified core area, then spread in a wider radius to come in touch with the outer limits of the neighboring styles in the course of time. Political eminence and economic prosperity no doubt played leading roles in the flowering and development of art, while a common religion provided a closer link between communities, although political frontiers and divergence of faiths appear to have been of no real consequence to the spreading of an art style and in the interchange of ideas and art forms.

By the seventh century, at least five distinctive styles had developed in the most prosperous regions of Southeast Asia: in the basins of the great rivers in Burma, Thailand, and Cambodia and in the coastal and maritime areas, including southern

5

AVALOKITESHVARA

India, Bihar, Kurkihar; about 900

Copper

6 ¾ in (17.1 cm)

Los Angeles County Museum of Art, from the Nasli and Alice

Heeramaneck Collection, Museum Associates Purchase

Vietnam, the Thai/Malay Peninsula, and the Indonesian archipelago. The main inspiring forces were Buddhism and Hinduism, which had found new homes and a new life among the various ethnic communities of Southeast Asia.

BURMA

Local tradition claims that Buddhism was introduced into Burma (now called Myanmar) during the third century B.C.E. by Emperor Ashoka's monk missionaries. The account of this alleged event echoes the episode found in Sri Lankan chronicles of the Buddha subduing the demon inhabitants of Sri Lanka on his first visit to the island; the Burmese also believe that the Buddha visited their country, and left his footprints upon the sand of a river and on top of a hill nearby. The origins of many historical and quasihistorical kingdoms are also traced back by Burmese chroniclers to the time of the Buddha, or even to the age of his predecessors.

The earliest indications of the existence of Buddhist culture in Burma have been found at the ancient sites of Peikthanomyo and Halin. Excavations at Peikthanomyo revealed foundations of stupas of a shape reminiscent of the south Indian Andhra and Sri Lankan Anuradhapura style of about the second or third century C.E., together with the remains of monastic cells of the type that prevailed throughout the Indian subcontinent at the same period. The major finds at Peikthanomyo, dated by the carbon 14 method to about 90 B.C.E.-300 C.E., reveal traces of a pre-Buddhist culture, followed by evidence of international maritime trade and a phase of transition from an indigenous lifestyle to one inspired by Buddhism.[9] The conspicuous absence of iconic images at the site may argue for its antiquity by relating it hypothetically to the "aniconic" art of India, or may simply indicate that perishable materials were used for icon sculptures.

Many states or city-kingdoms practicing Indian religions flourished in Burma during the seventh to the ninth centuries C.E. The Pyus and the Mons formed the two major ethnic groups, dominating the Irrawaddy River valley, and the delta and banks of the Sittang and Salween rivers, respectively. Indications

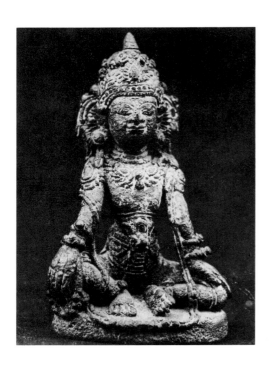

6

AVALOKITESHVARA

Burma, Pagan, Pannggu Temple; about 9th-11th century

Bronze

4 3/8 in (10.9 cm)

Archaeological Survey of Burma

of Theravada Buddhism using Pali as a canonical language are abundant among the remains of the Pyu city-kingdom of Shrikshetra, which evidently played a dominant role in the history of Burma from about the sixth to the ninth centuries. The script used in major inscriptions suggests a close relationship with Sri Lanka, the strongest bastion of the Theravada doctrine. Nevertheless, some other types of script related to northern India were also in use, and Sanskrit, the sacred language of northern Buddhism, occasionally appeared in inscriptions side by side with Pali and indigenous Pyu. Several streams of Buddhist traditions had evidently reached Burma and left indelible traces upon its material culture.

From the very beginning, Buddhist art and architecture of Burma bear unmistakable stamps of Indian styles, although Chinese influence may be observed in the constant use of radiating vaults—a technique practically unknown in India. Sculptures and figurative and decorative motifs associated with architecture all followed Indian conventions in both themes and style.

The oldest known Buddha images from Shrikshetra may date back to the sixth century, but the majority apparently belong to the seventh to ninth centuries. The most common type reveals a legacy of the Indian Andhra style in the heroic sitting pose (*virasana*); in the arrangement of the monastic robe, which leaves the right shoulder uncovered; and in the frequently inconspicuous form of the cranial protuberance (*ushnisha*).[10] The robe itself, depicted as thin and clinging to the body, reflects the idealizing nature of the classical Gupta and post-Gupta styles of India, while the gesture of meditation (*dhyanamudra*) is common to Sri Lanka and to the later Andhra style of southeast India. Such a coalition of similar types of stylistic elements from the Indian subcontinent is also seen in early Buddha images made in other parts of Southeast Asia, although each region had its own way of harmonizing and reproducing imported ideas. In Burma, there appears to have been a particularly strong impact from the post-Gupta tradition of Maharashtra and southwestern India, as is indicated by the frequent use of the spoked halo.[11] A touch of stylistic influence from medieval northeastern India led to the

7

VOTIVE PLAQUE

Burma, Myinpagan; about 9th-11th century
Bronze
4 in (10.3 cm)
Archaeological Survey of Burma

mode of representing the Buddha with the earth-touching gesture (*bhumisparshamudra*),[12] side by side with the more common gesture of meditation. The craftsmen of Burma readjusted and combined elements of many imported traditions and evolved their own image of the Buddha, in which the idealized traits of the Indian styles and their local ethnic features are blended.

Relief panels showing important episodes from the life of the Buddha and scenes of the Master attended by two divine figures or two monk disciples are common features of the vaulted temples.[13] Buddha images in bronze and gold often formed part of the ritual deposits enshrined within the stupas. A set of four identical Buddha figures occasionally adorns the four sides of relic caskets made of precious metals.[14] The accompanying inscription identifies them as the four Buddhas of the past—the historical Buddha and his three predecessors.

The veneration of Maitreya (Pali: *Metteyya*), the Buddha of the next age, must have reached Burma during an early time. A stone stele found inside the relic chamber of an important stupa now known as Khin Ba's mound shows five identical Buddha figures grouped around the drum of a stupa.[15] These probably represent the five Buddhas of the present age (*bhadrakalpa*), showing Maitreya in his potential status as the fifth Buddha in the series. The presiding image of the famous Mahamuni Temple in Arakan, which predates the eighth century, is also believed to have been a representation of Maitreya in the form of a Buddha.[16] A damaged figure of Maitreya from Shrikshetra is described as being clad in a monk's robe, but with matted hair and wearing a miniature stupa in his headdress[17]—the principal iconographic marks of Maitreya in the art of Mahayana Buddhism. The influence of the Mahayana doctrine, which evidently reached Burma by the seventh century, obviously introduced another concept of Maitreya, as one of the eight great bodhisattvas (*ashtamahabodhisattva*).

Sculptural remains at Shrikshetra include some representations of bodhisattvas. Divine attendants accompanying the Buddha in relief scenes from the vaulted temples occasionally look like a pair of bodhisattvas. This recalls a widespread motif in Indian art of the early Buddhist period when the cult of bodhisattvas began to gain

8

JAMBHALA

Indonesia, Java; 9th century

Bronze

5 ½ in (14.0 cm)

Mr. and Mrs. Gilbert H. Kinney collection

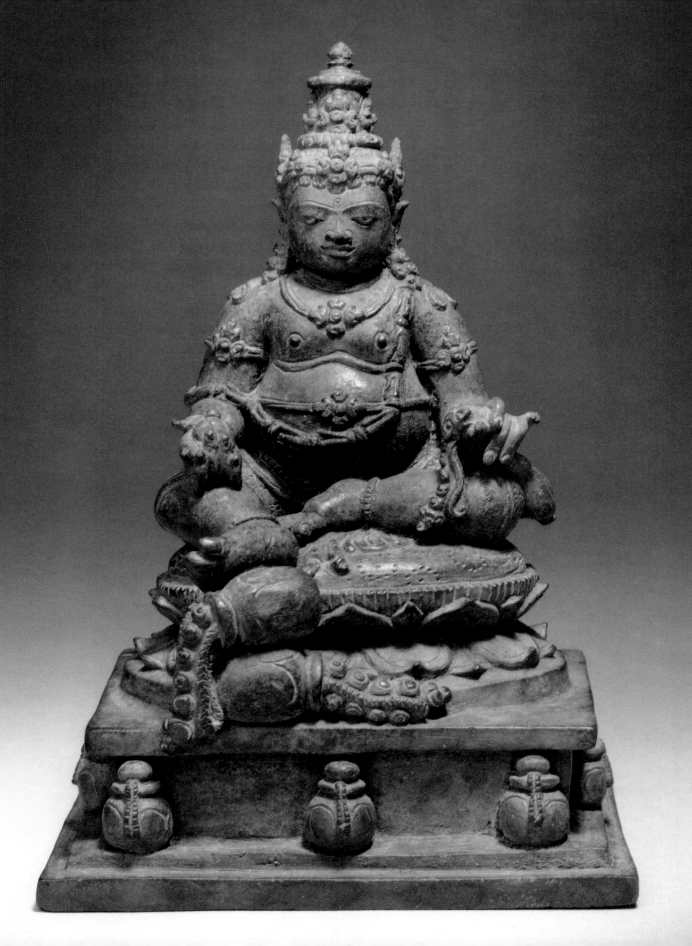

prominence, although the carvings themselves belong to the eighth or even the ninth century.

Isolated depictions of bodhisattvas began to appear during the seventh century. They are indications of the spread of Mahayana Buddhism, which also reached other parts of Southeast Asia in the same century. The finest—and earliest—bodhisattva image from Burma represents Avalokiteshvara, the most popular bodhisattva in the Mahayana tradition and the great savior who looks after the world of the present time, pending the advent of the Buddha Maitreya. This bronze figure,[18] recovered from the terrace of one of the principal stupas at Shrikshetra, shows Avalokiteshvara in a super-human form, having four arms and wearing rich ornaments typical of divinities. Standard Indian iconographical marks of this bodhisattva, namely the ascetic-style tresses and the miniature image of the celestial Buddha Amitabha worn on the crown, are faithfully reproduced. The mode of depiction is also close to that of India, recalling in particular the post-Gupta styles of Maharashtra and southeast India. But the imported ideas had become localized, and the image emanates above all a strong local character, replete with the full vigor and individuality of the Pyu tradition.

The eighth and ninth centuries marked the beginning of Burma's close contact with the flourishing Buddhist centers of northeastern India. Terra-cotta votive tablets of northeastern Indian types have been found among the remains of Pyu cities.[19] Some may have been imported, but many were undoubtedly locally made after northeastern Indian models.[20] Buddha images, triads consisting of the Buddha and two bodhisattvas, and isolated configurations of bodhisattvas and their feminine counterparts are the most common themes encountered on these tablets. After the Buddha, Avalokiteshvara was by far the most frequently represented personage. Some bodhisattva figures may depict Maitreya, but the identification remains uncertain due to the absence of specific iconographic marks.[21]

A remarkable type of bodhisattva image may be considered representative of the Pyu tradition. Characterized by the sitting pose known in Indian iconography as royal ease (*maharajalilasana*), and by an extraordinarily bulky crown and heavy jewelry, this type of figure appeared in the form of isolated statuettes in bronze,[22] and also in a triad in association with two Buddha figures.[23] Despite its display of Indian conventions in the sitting posture and mode of dress, the manner of execution and expression are distinctively indigenous. The majority of authors identify this personage as Avalokiteshvara,[24] who was often worshiped independently but at times formed part of the Buddhist triad in association with the Buddha Shakyamuni and the future Buddha Maitreya. In such group representations, Maitreya would have been depicted as the second Buddha figure, positioned to the proper right of the central one. This practice of portraying Maitreya in the form of a Buddha prevailed at

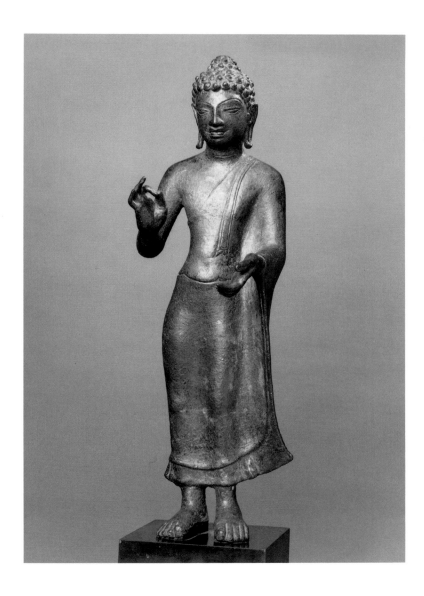

9

BUDDHA

Thailand, found near Phong Tuk; 8th century
Bronze
14 ¼ in (36.2 cm)
Robert Hatfield Ellsworth Private Collection

Shrikshetra, as attested to by the collective representation of the five Buddhas of the present eon mentioned earlier.[25]

Minor sculptures, as a rule, show more freedom of movement and more animation than icon figures, which were usually bound by rigid iconographical rules and conventions. Delightful examples appeared on terra-cotta reliefs adorning the monuments at Shrikshetra, and at Pegu and Thaton in the Sittang and Salween valleys. Some seem to relate stories of the previous lives of the Buddha, in which ascetics, princes, and demons played important roles.[26] The figurative forms, molded in malleable clay, frequently exhibit a degree of sensitivity and spontaneity approaching that of classical

India. The dancing and frolicking dwarfs of Pegu[27] also compare favorably with the best depictions known of such themes in India and Sri Lanka. Bronze figures of musicians and dancers, recovered from the relic chamber of the Payagyi stupa at Shrikshetra,[28] are unique in their context, and are among the most elegant and expressive sculptures of Southeast Asia.

The Pyu culture of Burma declined after the last of its city-kingdoms succumbed to the attack of Nanzhao, a rising political power in the south of China, in 832 C.E. Nevertheless, the influence of its artistic tradition remained discernible in the Irrawaddy valley until about the twelfth century.

THAILAND

Local inscriptions and Chinese historical accounts mention a number of political and cultural centers in present-day Thailand during the seventh to the ninth centuries. The entire country may be geographically as well as culturally divided into three parts, namely the central zone, the northeastern and eastern zone, and the peninsula.

CENTRAL THAILAND

In this region are the central plains and the basins of the Chao Phraya and Meklong river valleys, where many archeological sites have been located. Several features of the existing evidence indicate a process of cultural continuity in the area, extending from prehistoric periods into historical times.[29] The site of U Thong, in particular, has produced a large variety of objects of trade that attest to its active role in the international sea trade of the early centuries of the Common Era.[30] Local tradition in Thailand claims that Ashoka's missionaries landed near Nakhon Pathom in the lower Chao Phraya valley in the third century B.C.E., and that Buddhism became established in the country from that time onwards. The factual evidence of contact with India actually dates from many centuries later, and no Buddhist finds can be dated earlier than the fourth century C.E.[31]

Many cultural centers developed in the fertile valley of the Chao Phraya River, which was also easily accessible from the

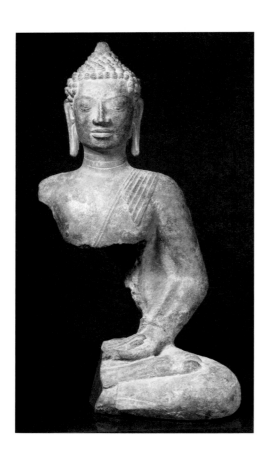

10

BUDDHA

Thailand; 8th century
Bronze
About 28 in (71.1 cm)
Private collection

coast. During the sixth to the ninth centuries, the dominant power in this region was apparently Dvaravati, a Buddhist kingdom referred to in the records of Chinese pilgrims of the seventh century, the name of which has been found on many silver coins recovered from the area.[32] Theravada Buddhism, using a Pali canon, was Dvaravati's predominant religion, although Hinduism has also been attested to by some local finds. Major inscriptions were generally written in Pali, and occasionally in the native Mon.[33] Sanskrit has appeared in a number of inscriptions in a Hindu context, and also in the service of kingship.[34] Very little is known of the scope of the political authority of Dvaravati, but it was undoubtedly an important center of Buddhist culture and the focus of a homogenous art style that exerted a strong influence in all parts of central Thailand, extending even into the eastern and southern zones, where other types of local culture prevailed.

Buddhist sculptures revealing characteristics of the Dvaravati style appear to have been most numerous during the seventh to the ninth centuries, which obviously represents the high period of this culture. Pieces of exceptional quality came from the modern provinces of Suphan Buri, Nakhon Pathon, Rat Buri, and Lop Buri, which, no doubt, constituted the geographic nucleus of this art tradition. (Finds from different sites were expertly classified by Dupont in 1959,[35] and discussions of new materials and proposals of new theories have been presented by other scholars, in particular Quaritch Wales and Boisselier.)[36]

True to the Theravada faith, the main inspiring force of its art, the sculptures of Dvaravati consist largely of images of the Buddha, narrative scenes from his life and former lives, and free-standing stone wheels that symbolically represent his doctrine. Standard configurations of the Buddha became established by the seventh century. In these, a coalescence of the Indian Andhra, Gupta, and post-Gupta traditions,[37] similar to that which can be observed in early Buddha figures made in other styles of Southeast Asia, are readily recognizable. Seated images are most often in the heroic pose, while the hands usually rest on the lap in the gesture of meditation. These are features common to southern India and Sri Lanka, especially after the sixth century.

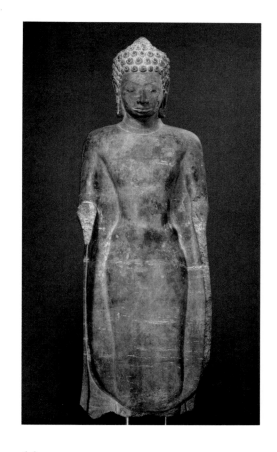

11

BUDDHA

Thailand; 8th century

Limestone

36 ½ in (92.7 cm)

The Asia Society, The Mr. and Mrs. John D. Rockefeller 3rd Collection

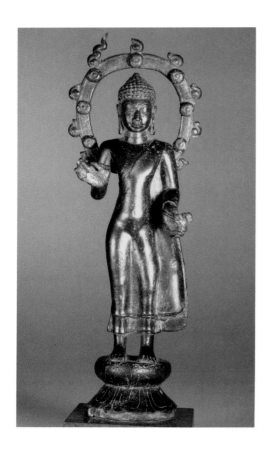

12

BUDDHA

Thailand; 8th century
Bronze
About 18 in (45.7 cm)
Private collection

Another gesture, that of elucidation (*vitarkamudra*), usually assumed when the figure is seated in the "European" pose (*pralambitapadasana*), apparently was an element of the classical Gupta tradition, which reached Dvaravati via southern India or Sri Lanka. The thin and transparent robe, worn in the open mode, reflects an impact of the Gupta and post-Gupta traditions upon the Andhra style of the southeastern coast. When standing, the Buddha is usually clad in a thin and clinging robe, worn in the covering mode, typical of the classical Gupta style of northern India and occasionally encountered in the style of the Gupta/Vakataka of Maharashtra. The hands, raised symmetrically, make the symbolic gesture of elucidation, repeated twice in an un-Indian manner.

The physical form and physiognomy of the Dvaravati style maintain the outlines of the idealized formulas of India, but ethnic traits characteristic of the Mon people are constantly manifest. The standard form is rendered smooth and nonmuscular after the conventional Indian mode of depicting divine and spiritual beings, but recalls in particular the impressive monumental look of the Gupta/Vakataka style of Maharashtra. Indigenous features are most distinctive in the broad face, high cheekbones, prominent eyes, full lips, and curved eyebrows, which are heavily accentuated and joined. There is also a strong local preference for severe frontality of stance, solid and calm dignity, and an introspective expression (see [13]).

Influences of the artistic tradition from Bihar and Bengal in northeastern India introduced some new iconographic and stylistic elements, which were also incorporated into images of the Buddha. Among the products of the late eighth and ninth centuries, the diamond pose (*vajrasana*) and the earth-touching gesture, as well as a jewel-like ornament upon the cranial protuberance and a folded lappet of the robe upon the left shoulder (see [10]), frequently appear.

Dvaravati relations with the Thai/Malay peninsula also helped to introduce certain stylistic features and a new aesthetic concept regarding the configuration of the Buddha. The right hand of the standing image may thus be seen reaching down and displaying

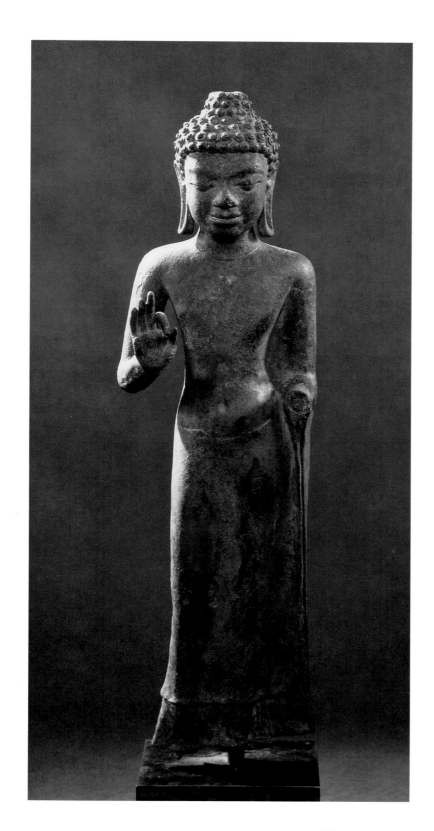

13

BUDDHA

Thailand; 8th century
Bronze
20 ½ in (52.0 cm)
Alsdorf Collection, Chicago

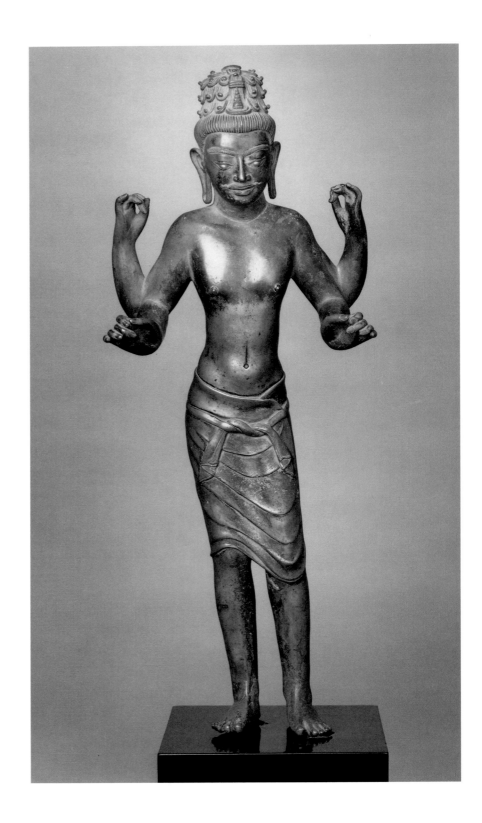

14

MAITREYA

Thailand;
early 8th century
Silver with inlaid eyes
18 ¼ in (46.4 cm)
Robert Hatfield Ellsworth Private Collection

the gesture of benediction (*varadamudra*), while the left, slightly raised, is empty or holding the end fold of the robe. Or, the right hand may retain the gesture of elucidation, while the left, extended downwards, displays an empty open palm or holds the end fold of the robe (see [12, 13]). The robe may be worn in the open mode much favored on the peninsula. The physical form usually becomes more slender and the standing pose more elegant than in the standard type. The strict frontality common to Dvaravati style is often relaxed into a flexed stance, and the facial expression is more benign.

Mahayana Buddhism, which swept over Southeast Asia in the seventh century, appears to have found a prompt response in Dvaravati culture, but Theravada Buddhism still remained predominant throughout. Divine personages introduced by the new system were given the role of Buddha's attendants or associates. Bodhisattva images began to appear in the seventh century, to become a sporadic but not unimportant phenomenon in Dvaravati culture until the ninth century. The earliest examples, represented by a number of large terra-cotta sculptures discovered at Ku Bua in Rat Buri,[38] probably functioned as acolyte figures to the Buddha. Among them, Avalokiteshvara, Maitreya, and Vajrapani can be identified. Stylistically, this series of bodhisattva figures appears to have been inspired by the classical Gupta style of northern India and its prolongation in Maharashtra. The presence of bodhisattvas in the heartland of Dvaravati need not imply a doctrinal change in that culture, but merely underlines the growing significance of Mahayana concepts in that originally and still predominantly Theravada community. A similar parallel existed in Sri Lanka during the same period.

Cultural relations with the flourishing Mahayana centers in northeastern India and maritime Southeast Asia obviously reinforced the popularity of bodhisattvas. Besides assuming the role of Buddha's attendants and companions, some of them, like Avalokiteshvara, may have enjoyed an independent worship. A number of isolated bodhisattva figures in bronze and terra-cotta are known to exist from the eighth and ninth centuries, and many represent Avalokiteshvara.[39] Some show stylistic influence from

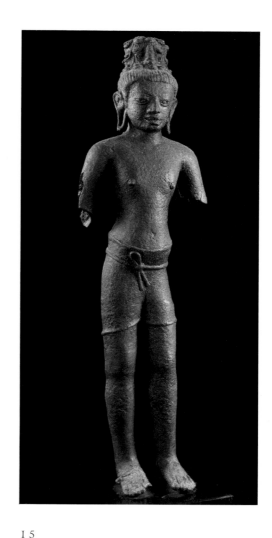

15

MAITREYA

*Thailand, excavated at Ban Fai
(Lam Plai Mat); 8th century
Bronze with inlaid eyes
27 ½ in (69.9 cm)
National Museum, Bangkok*

35

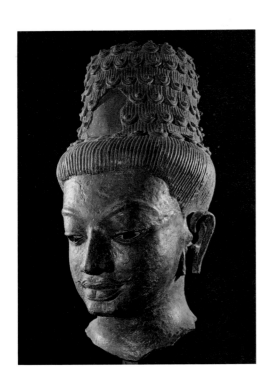

16

HEAD OF A
BODHISATTVA

Thailand, excavated at Ban Tanot; 8th century

Bronze

27 ¼ in (69.2 cm)

National Museum, Bangkok

northeastern India in the full body and the detail of jewelry, while others display slender proportions and a graceful stance, and are often clad in a heavy pleated dhoti typical of a type of bodhisattva figure produced in the peninsula and the Indonesian archipelago (see [24]).

At Si Thep, an ancient urban site situated at the crossroads of the main routes linking the central plains with the northeast, the Buddhist tradition of Dvaravati met and flourished in juxtaposition with a Hindu culture, which was closely affiliated to that of Cambodia.[40] Besides many magnificent images of Hindu deities, the recorded finds at the site and its environs include a series of large Buddha and bodhisattva figures carved on the wall of a cave[41] and a set of gold plaques bearing repoussé depictions of bodhisattvas and other Buddhist divinities.[42] Maitreya, the future Buddha, appears in both series. There is a stylistic connection between the rock-cut bodhisattva figures at Si Thep and the contemporaneous bronze sculptures from eastern Thailand (see [14, 15, 17, 18, 19, 34]). The repoussé images on the gold plaques, however, were executed in the Dvaravati style of central Thailand.

NORTHEASTERN AND EASTERN THAILAND

This division comprises the valleys of the Chi and Mun rivers, the Khorat plateau, and the basin of the Prachin River, which is directly connected to Cambodia through the passes of the Dong Raek range. Strong political and cultural links with Cambodia are evident from the large number of inscriptions left by Cambodian kings of the seventh century[43] and also from the remains of Hindu temples built in the seventh- to ninth-century styles of pre-Angkor Cambodia.[44]

A number of ancient settlements whose religious life was largely dominated by Buddhism and Hinduism lay scattered in this vast region. Offshoots of the Buddhist culture of Dvaravati and the art it inspired penetrated throughout the entire area, leaving substantial vestiges at all its major centers. In the Chi and Mun valleys, the Dvaravati Buddhist culture met and blended with a local megalithic cult, resulting in the production of an astounding number of large stone stelae carved with Buddhist scenes and

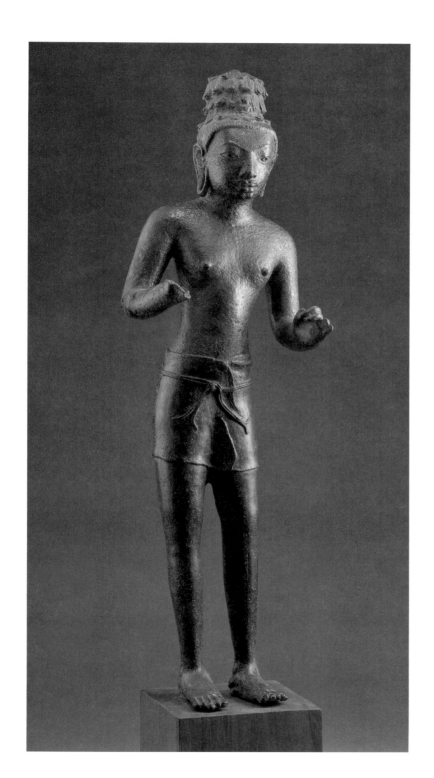

17

AVALOKITESHVARA

Thailand; 8th century
Bronze
21 in (53.3 cm)
Denver Art Museum

18

AVALOKITESHVARA

Thailand, excavated at Prakhon Chai; 7th century
Bronze with inlaid eyes
27 ½ in (69.9 cm)
Asian Art Museum of San Francisco,
The Avery Brundage Collection

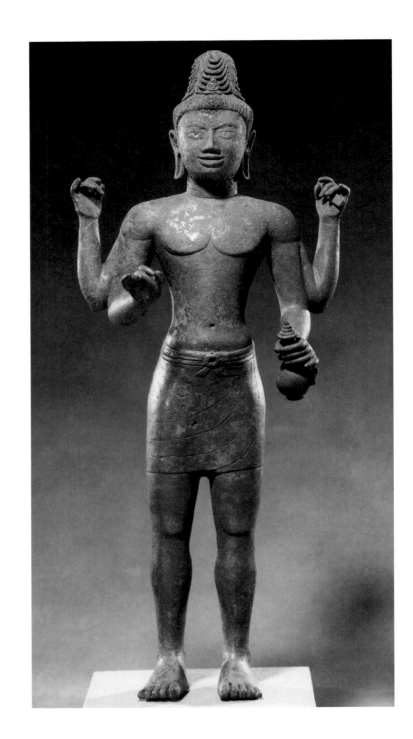

symbols.[45] The sculptural style shows a strong impact of Dvaravati mixed with some elements of pre-Angkor Cambodia and a certain amount of influence from Champa, on the eastern shores of the continent. An ancient land route connected the Cham country with the Chi and Mun valleys, and provided further access to the central plains of Thailand.

Maha Sarakham, in the Chi valley, also produced an abundant quantity of terra-cotta votive tablets that once adorned Buddhist stupas[46] and a series of interesting silver plaques containing repoussé images of the Buddha, bodhisattvas, and other divinities.[47] The treatment of the figures is quite characteristic of the local idiom of the Dvaravati style.

Cambodian influence was at its strongest in the eastern zone of Thailand. The most spectacular finds from this region are a particular type of Buddhist bronze. The largest group of these, consisting of more than three hundred pieces, was discovered at Prakhon Chai in Buriram Province, in 1964 (see [14, 17, 18, 19, 23, 34]).[48] Three more images, found in Lam Plai Mat at Ban Fai in the same province, were presented to the National Museum at Bangkok in 1971 (see [15]).[49] Prior to the discovery of these two groups, fragments of a colossal bronze figure of the same type had been excavated at Ban Tanot, in Nakhon Ratchasima Province (see [16]).[50]

There are only a few depictions of the Buddha among these finds, which consist almost entirely of bodhisattva figures. The Buddha images (see [20]) are close in style to Dvaravati products of central Thailand, but the faces reveal a sharper delineation, and one particular image from Prakhon Chai has a mustache, which is alien to Dvaravati style.[51] The physical frame is comparatively less massive and the robe more elegantly displayed.

Bodhisattva images, on the other hand, were made in the style of pre-Angkor Cambodia. Even if the subject matter did not belong to the mainstream of that tradition, the stylistic features of these Buddhist sculptures followed the same steps of evolution as shown by the pre-Angkor styles of Prei Kmeng, Prasat Andet, and Kampong Preah of the late seventh to ninth centuries. They form a more or less unified group, containing within it an

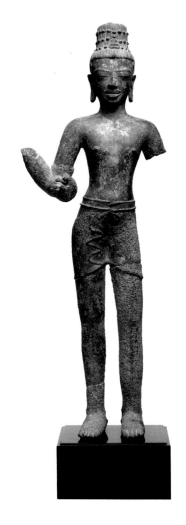

19

AVALOKITESHVARA

Thailand, attributed to Prakhon Chai;
late 8th–early 9th century
Bronze
32 in (81.3 cm)
Private collection

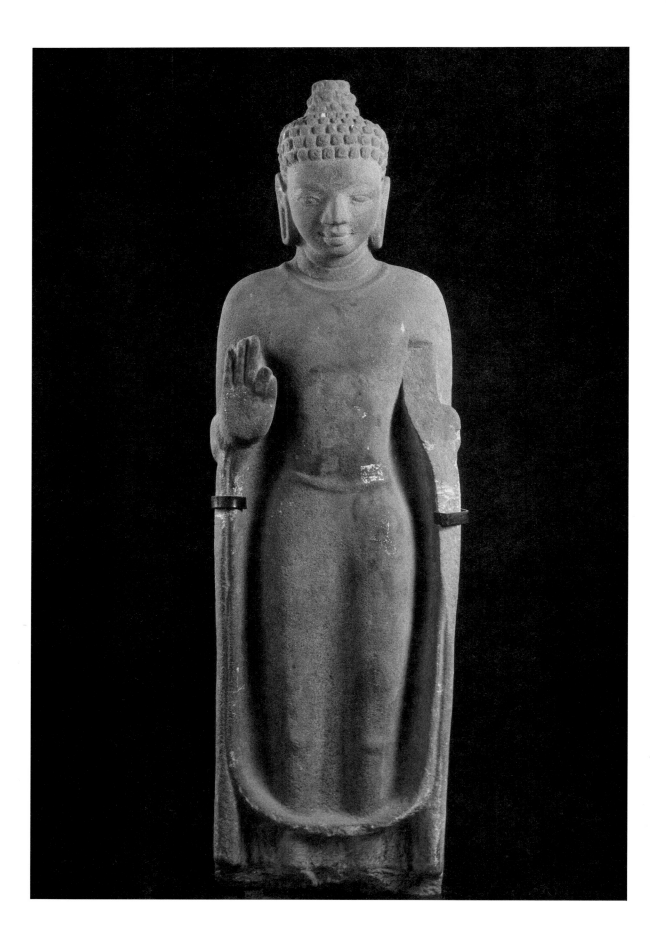

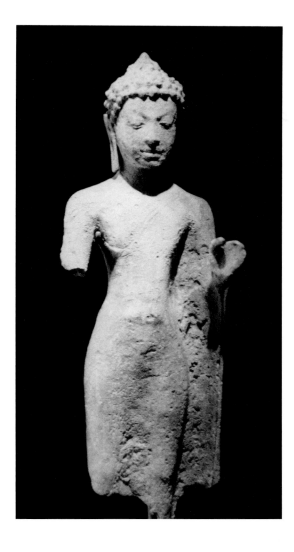

internal process of evolution along the same lines as the sculptures of Cambodia proper.

Most of the bodhisattva images are representations of Avalokiteshvara and Maitreya portrayed in purely ascetic form, characterized by a slender body and utter simplicity of dress. The earliest among them may date from the end of the seventh or the early eighth century [18], but the majority belong to the eighth and ninth centuries. The early pieces, remarkable for their delicate form, relaxed pose, and supple movement, emanate a strong sense of dignity and grace (see [16, 18, 34]). In the later examples, the contour became hardened, while the posture tended to be stiff and the hairlines and details of garments schematic and formalized (see [1, 14, 15, 17, 19]).

Belonging to the same artistic tradition as that of Cambodia proper, the bronzes from eastern Thailand were obviously locally cast; bronze sculptures are notably few

among the material remains of Cambodia proper. The varying quality of the pieces, the large quantity of the Prakhon Chai hoard, and the long span of production, which stretches from the end of the seventh to the ninth century, all suggest the existence of some local workshops of long-standing traditions, specializing in the manufacture of Mahayana Buddhist bronzes. Some smaller items from the Prakhon Chai hoard[52] also show signs of being local modifications of Cambodian formulas. More examples of this hybrid type are supplied by a group of four silverlike images representing the Buddha, Avalokiteshvara, and two goddesses, discovered at Khon Buri in Nakhon Ratchasima Province.[53] All these were obviously products of local workshops, showing a synthesis of Dvaravati and pre-Angkor styles mixed with a considerable measure of indigenous traits.

The distribution of these bronzes encompasses the Khorat plateau and the province of Buriram, where a number of small states or kingdoms is known to have existed in the proximity of the powerful Cambodian kingdoms of the seventh to ninth centuries. Local inscriptions preserve some names, including that of Shri Canasa, which was mentioned in a few records of the seventh and tenth centuries. Theories and speculations have been built up on the connection between the Prakhon Chai, Lam Plai Mat, and Ban Tanot bronzes with this kingdom, but there seems to be no real evidence to justify this.[54] The location and extent of power of Shri Canasa remain unspecified, but it probably was only one of the many states or centers forming part of the changing political pattern of the time.

Among ancient settlements in eastern Thailand, the site of Muang Phrarot, in Prachin Buri Province, is particularly rich in remains of Buddhist and Hindu culture.[55] Buddhism and Hinduism flourished there side by side, recalling the situation encountered at Si Thep on the border between central Thailand and the eastern zone. The style of the Buddha images may be called an eastward extension of the Dvaravati style, although it reveals some characteristic regional traits and shares a few stylistic elements with the art of the peninsula. Despite the usual display of features characteristic of Dvaravati style, Buddha images from Prachin Buri may frequently be distinguished from the products of the central plains by their gentler expression and more elegant physical form. The facial features, in general, seem to be more delicate, showing a less pronounced ethnic Mon type. Also characteristic of this eastern idiom of Dvaravati style is a crisp treatment of lines and clear definition of forms.

THE THAI/MALAY PENINSULA AND INDONESIA

One may draw a tentative line to divide maritime Southeast Asia into two parts: the western zone, which includes the Thai/Malay Peninsula and Sumatra, and the eastern

zone, which consists of all the other islands in the area, with Java and Bali the two most significant of these.

Art-historical and archeological remains of the western zone are often grouped under the heading of "Shrivijaya style," since the region once formed part of a powerful kingdom of that name.[56] The extent of the political authority of Shrivijaya is still unspecified, and the location of its capital remains a matter of controversy. It seems quite likely that its political frontiers fluctuated through the centuries, with the focal point of its powers shifting accordingly. Nevertheless, present evidence makes it clear that Palembang in Sumatra and Chaiya on the peninsula were important cultural centers of Shrivijaya during the seventh to the ninth centuries.

Hinduism appears to have been the first major religion to become firmly rooted in maritime Southeast Asia. The Thai peninsula has produced a number of ancient Vishnu images, which may date back to the fourth or fifth century,[57] while Kalimantan and Java have yielded evidence of Hindu kingdoms that existed on these islands in the fifth century.[58] Buddhism had also appeared by this time, but still found little response on the islands when the Chinese pilgrim Faxian passed through Java in 414 C.E. The situation could have changed rapidly after the time of Faxian, since the famous monk Gunavarman, traveling from India to China in 420 C.E., is credited by the Chinese chroniclers with having converted many royal persons to Buddhism during his sojourn in the archipelago.[59]

The Thai/Malay Peninsula, in the western zone, preserves the earliest local epigraphical records of the presence of Buddhism, dating back to the middle of the fifth century,[60] and also a large quantity of Buddhist finds from the sixth to the ninth centuries and beyond.[61] There are indications of Dvaravati culture penetrating to the south, bringing with it Pali Buddhism and its conventional art style, the influence of which remained discernible at many places against the background of a locally developed Buddhist culture using Sanskrit in its sacred writings. Buddhism persisted in the peninsula side by side with Hinduism until around the end of the eighth century, when it

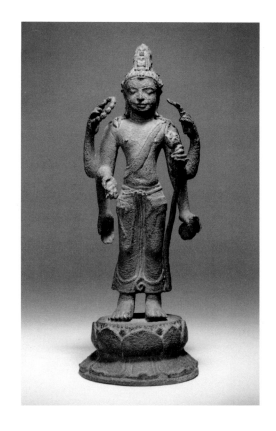

22

AVALOKITESHVARA

Thailand; 9th century
Bronze
9 ¼ in (23.5 cm)
Mr. and Mrs. Gilbert H. Kinney collection

23

AVALOKITESHVARA

Thailand; 8th century
Bronze
14 in (35.6 cm)
Robert Hatfield Ellsworth Private Collection

opposite

24

MAITREYA

Thailand, excavated at Ban Lan Khwai;
8th century
Bronze
6 ⅜ in (16.2 cm)
National Museum, Bangkok

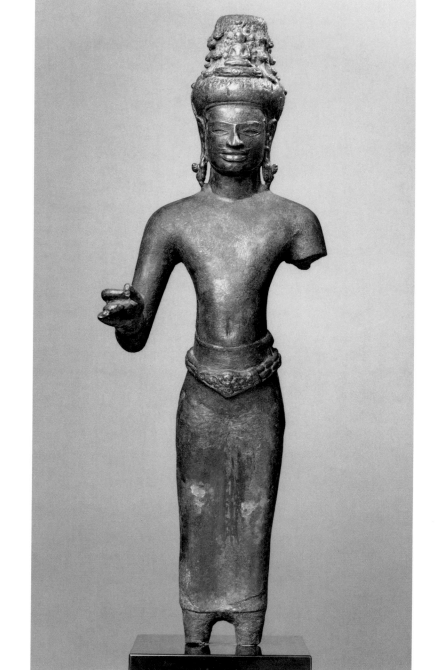

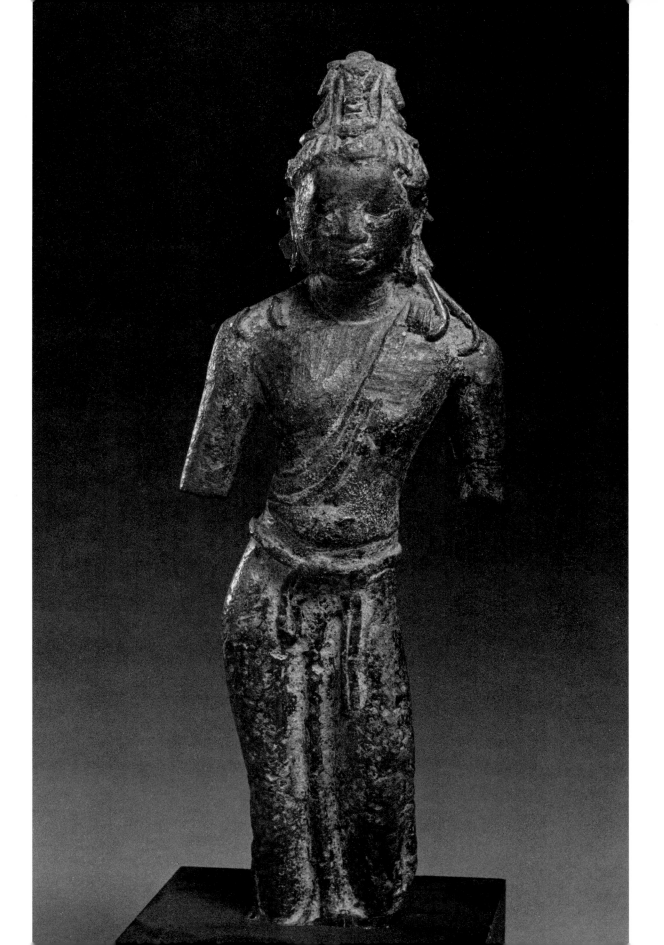

received a great stimulus from the powerful Shailendra dynasty and then attained a predominant position. A slightly different situation existed in Sumatra, where Buddhism appears to have been the most prominent religion from the seventh century onwards.

The islands in the eastern zone have also produced some bronze Buddha images, the oldest of which may date from about the sixth century,[62] but the predominant religion in the entire zone from the fifth century onwards seems to have been Hinduism. On the evidence of inscriptions, two Hindu kingdoms existed in western Java and Kalimantan in that century, and there are indications of a prolongation of Hindu culture in western Java till the seventh century, in which period Hindu temples began to appear on the Diyeng plateau in central Java.[63] The rise of the Shailendra power in the late eighth century brought Buddhism to great prominence in most parts of the Indonesian archipelago, but Hinduism regained its preeminence in Java and Bali by the end of the ninth century.

Artistic influences from the Indian subcontinent similar to those seen in the standard configurations of the Buddha in the Dvaravati style are present in the earliest type of Buddha image produced in maritime Southeast Asia; most noticeable are the impact of the Andhra or Sri Lankan tradition and of the late Gupta and post-Gupta styles of Maharashtra. Seated images, as a rule, assume the heroic pose and the gesture of meditation, and are clad in a thin monastic robe worn in the open mode.[64] Standing images, usually seen in a frontal pose, often display the gesture of elucidation or a variant of it with the right hand, while the left hand grasps the folded end of the robe. The physical frame, in general, is broad but smoothly modeled, with a simplified contour.[65]

Another type of Buddha image was apparently based on some classical Gupta prototypes from northern India, although it retained some elements of the southern styles of the Indian subcontinent. This type makes the gesture of benediction with the right hand, and the left hand, which is slightly raised, holds the folded slip of the robe. The body usually looks soft and supple, and the standing pose strikes an elegant note.[66]

Stylistic influences from medieval northeastern India were particularly strong in Buddhist sculptures made during the period of Shailendra supremacy, from the late eighth to the middle of the ninth century. These can be seen in a highly sophisticated treatment of the Buddha form, the elaboration and refinement of ornaments adorning the throne, and the display of a variety of hand poses, while the sitting pose known as the diamond seat replaced the heroic pose introduced earlier with the southern styles of the Indian subcontinent.[67] The Shailendra mode of depiction established a new standard formula for Buddha images, which became widespread in all parts of maritime Southeast Asia. The style of the earlier age, however, persisted in some localities,

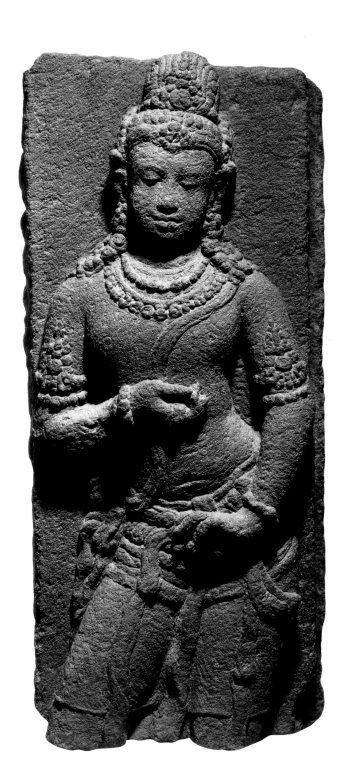

25

DANCING DIVINITY

Indonesia, Java; 9th century
Stone
30 ½ in (76.25 cm)
Susan L. Beningson collection

as can be seen in the occasional appearance of a heavy figure type and in hand poses that still retain the mannerisms of the southern styles of the Indian subcontinent.[68]

Mahayana Buddhism, rich in iconography and in expressions of metaphysical concepts, was the inspiring faith of the Shailendras, under whose patronage Buddhist art attained an unrivaled efflorescence and perfection. The glory of Buddhist art under the Shailendras is manifest in the magnificent monuments they built in central Java and by the abundance and wide variety of sculptures in stone and bronze produced in practically all parts of maritime Southeast Asia during the period of their supremacy.

Icon sculptures consist of depictions of Buddhas both human and divine, bodhisattvas, Taras, and other gods and goddesses of the extensive Mahayana pantheon. Bodhisattvas played important roles as independent saviors, as well as forming a group of eight to watch over the eight directions of the cosmos. Avalokiteshvara, Maitreya, and Vajrapani were frequently depicted, although the most popular of them all was Avalokiteshvara, to whom many functions and manifestations were ascribed.

Bodhisattva images had also appeared in the art of maritime Southeast Asia prior to the time of the Shailendras. The earliest examples known followed the ideals of the classical Gupta age and revealed much of the sophisticated simplicity and noble elegance typical of that Indian style.[69] By the eighth century, stylistic elements of the Pallavas of southeast India begin to appear in combination with those of the other post-Gupta styles from Maharashtra and southwest India.[70] One particular type of bodhisattva image reveals strong influences of the Pallava style in the slender form of the body, the cylindrical mass of hair, and the simple garment made of rather heavy and pleated material (see [24]). In some cases, there is a lingering influence of the classical Gupta tradition manifest in an elegant stance and supple limbs.

A group of bodhisattva figures, mostly from Sumatra,[71] displays pronounced stylistic traits of the Chalukya tradition of southwest India in the extraordinarily sensitive treatment of the body and facial lines, as well as in the special types of jewelry the figures wear. One item included here [26] belongs to this category.

A relationship with Sri Lanka, which had developed its own mode of depicting bodhisattvas by the eighth century,[72] is also reflected in a number of bronze sculptures from maritime Southeast Asia.[73] These appear to have been modeled after a special type of Sri Lankan image of Avalokiteshvara, depicting him in a purely ascetic manner, with a cylindrical mass of hair, a thick pleated dhoti, and a large piece of stylized tiger skin wrapped around the hip and pulled up across the chest (similar to [27]). A bronze image of Avalokiteshvara in the Rijksmuseum in Amsterdam obviously represents a local adaptation of this Sri Lankan type, as can be seen in the large expanse of a tiger skin draped around the thick dhoti,

and the tall and heavy cylindrical mass of hair.

Representations of Buddhas, bodhisattvas, Taras, and other Mahayana deities attained standardization in iconography and stylistic treatment during the Shailendra period, under the strong influence of medieval northeastern India. And yet, two styles of depicting bodhisattvas and other divine figures appear to have prevailed side by side throughout the late eighth to tenth centuries. The first represents a continuation of the earlier mode of depiction inspired by the southern styles of the Indian subcontinent (see [24, 26, 32]). The other reveals distinctive stylistic traits of early medieval northeast India, characterized by a figure type with a soft and rounded volume (cf. [5]). The fusion or coalition of the elements of these two coexisting styles also occurred in various ways. The iconic formula and mode of dress typical of northern India may be combined with the slim and compact figure inspired by the southern styles (see [30]), or the full-figure type typical of the north may be adorned with ornamental girdles and other jewelry borrowed from southern styles. Many combinations of stylistic elements also appear in the lesser sculptures and the countless figures in relief panels adorning the monuments of the Shailendras in central Java.

Traces of the Dvaravati tradition can be seen as far south as Pattani.[74] A wave of stylistic influences from Champa also reached peninsular Thailand, and left substantial vestiges at Chaiya during the course of the ninth century.[75] Countercurrents from the peninsula kept flowing into central and eastern Thailand during the eighth and ninth centuries. Chinese and Arabic records of the political relations between the Indonesian islands and the mainland may be substantiated by the occurrence of some new motifs in the art of Cambodia and Champa during the late eighth and ninth centuries.

CAMBODIA

In the seventh century, the center of political gravity in Cambodia shifted from the delta region of the Mekong River to its middle basin. Ishanapura, probably known to the Chinese as Zhenla and identified with the site of Sambor Prei Kuk, was by far the most

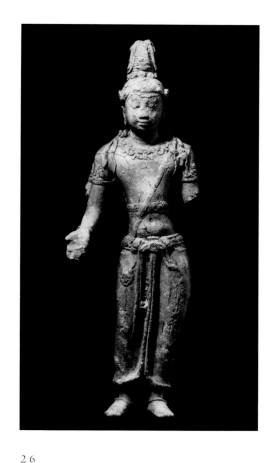

26

BODHISATTVA

Indonesia, Sumatra; late 7th-early 8th century
Bronze
8 ¼ in (21.0 cm)
Robert Kipniss collection

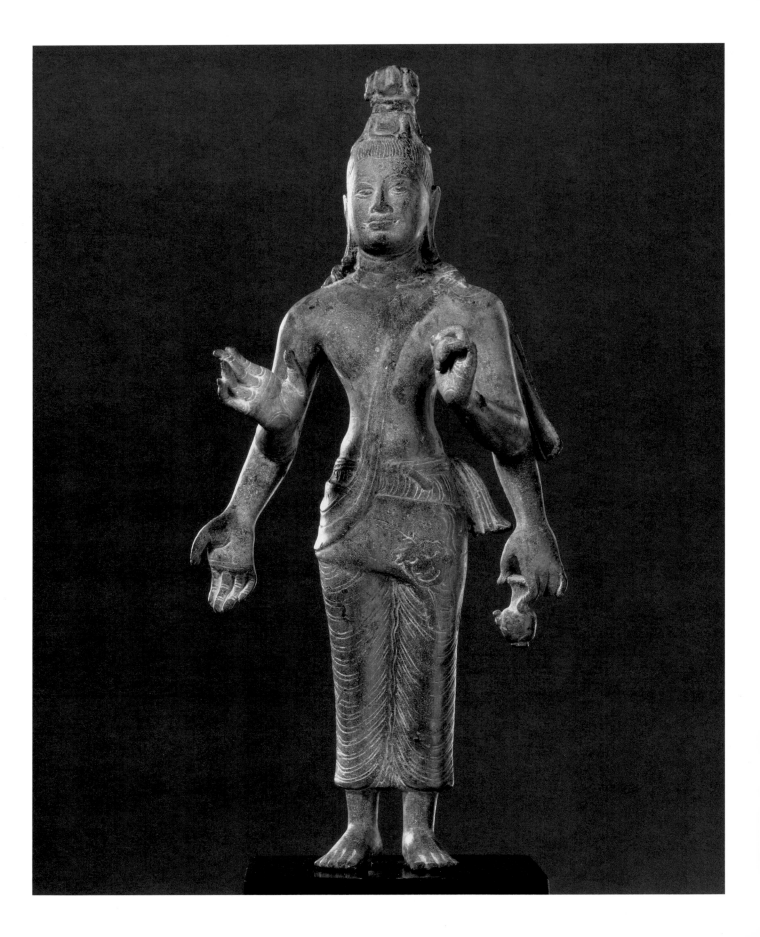

powerful kingdom, and its military strength was felt by many other political centers of the time. The hegemony of Ishanapura declined in the eighth century, and small competitive states or kingdoms rose up in different parts of the country. Each maintained a certain degree of territorial autonomy until the beginning of the ninth century, when a large part of Cambodia became united by Jayavarman II, the founder of the great consolidated kingdom of Angkor.

The major monuments of the seventh century—those at Sambor Prei Kuk—present a variety of interesting architectural forms and a rich array of sculptures and decorative motifs. The main sources of their artistic inspiration can be traced back to the Gupta/Vakataka style of Maharashtra and the post-Gupta styles of southwest and southeast India.[76] The monuments were by no means imitations of any known Indian models, and bear clear witness to an ingenious process of selection, modification, and correlation of imported elements by local craftsmen. A new style had been formulated, showing many characteristic traits that would continue to develop during the centuries to come. figurative sculptures, too, had left the initial period of strong Indian influences behind, although some idealized traits of the Indian tradition still lingered on.[77] In contrast to the other styles of Southeast Asia, there are no further indications of Indian influence on Cambodian art after the seventh century; the art of Cambodia proceeded to live on its own resources and develop its own course of evolution. Close contacts with neighboring Champa and a relationship with Indonesia introduced new stylistic elements in the late seventh to ninth centuries, but these quickly became localized and absorbed into the mainstream of Cambodia's own style.

Hinduism was by far the predominant religion and the main source of spiritual inspiration for artistic activity; Buddhism had been practiced in Cambodia since the sixth century, but remained a minor religion throughout the pre-Angkor period. Buddhist finds of the seventh to ninth centuries consist mainly of Buddha and bodhisattva images. The first Buddha images known were carved in sandstone and may

27

AVALOKITESHVARA

Sri Lanka; 7th–8th century
Bronze
8 ¾ in (22.2 cm)
The Asia Society,
The Mr. and Mrs. John D. Rockefeller 3rd Collection

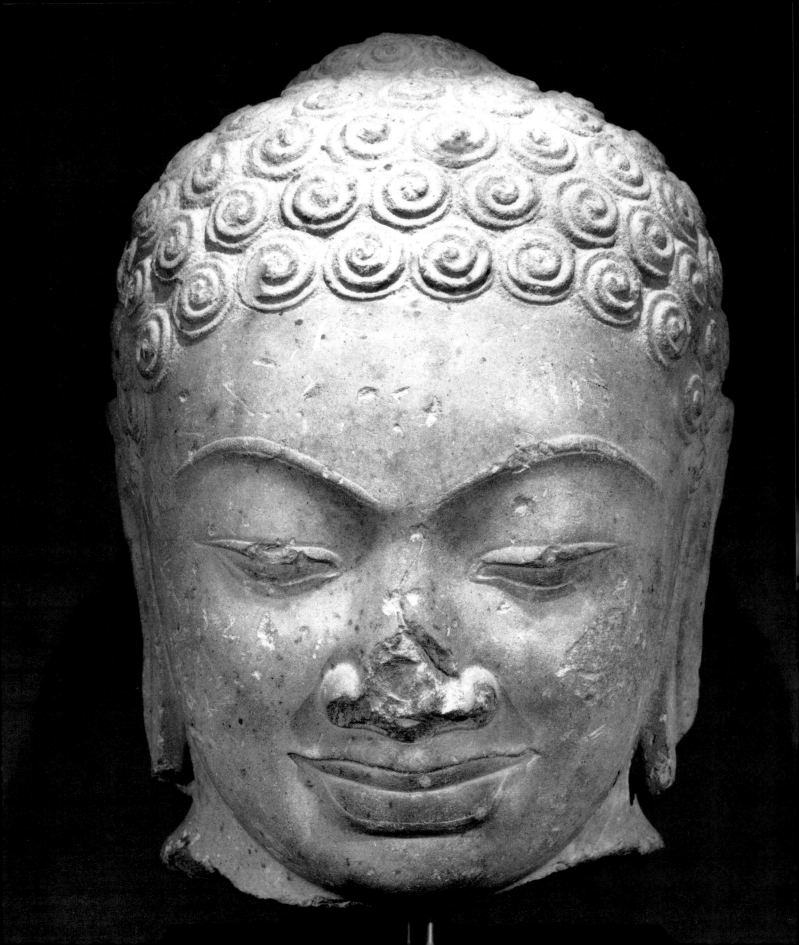

date from the late sixth or early seventh century. There may have been earlier examples made of wood, which was the earliest building material in Cambodia: a few Buddha figures made of wood have been found preserved in the wet clay of the delta.[78]

The earliest known Buddha images in Cambodia come from Angkor Borei, an important seat of political power prior to the sixth century, which apparently retained its significance as a cultural and artistic center for another century or more.[79] These images have stylistic features of the early Andhra style of southern India, modified by the influence of the Gupta tradition. The archaic elements of Andhra are still conspicuous in the very low or almost nonexistent protuberance of the skull, the elongate shape of the head and face, and the large flat spiral curls (see [28]). The robe, heavy and pleated in the Andhra tradition, became smooth and clinging under the impact of the Gupta influence, which also introduced a gentler, more delicate modeling and a gracefully flexed pose.

A larger group of figures, collected from many sites, bears a close stylistic similarity to the standard type of Dvaravati products, and may date from the eighth and ninth centuries.[80] This group is characterized by a broad physical form with a simple contour and smooth modeling, a broad face with heavy features, and full lips. The general description recalls the outline of the standard formula of the Dvaravati style, but the figures clearly reflect a different ethnic type, lacking the prominent eyes and the frequently met severe countenance of Dvaravati images. The eyebrows often meet in a wide-angled ridge instead of forming a continuous curve. The facial features are more sharply delineated than in the Dvaravati style, although the expression is usually more amiable. The general treatment of the contours and facial lines is quite crisp, recalling to some extent the eastern idiom of the Dvaravati style at Prachin Buri. When standing, the Buddha figure assumes a frontal pose, raising the right hand either in the gesture of elucidation or in the gesture of reassurance (*abhayamudra*), balancing the left hand, which usually holds the folded end of the robe. This robe, in contrast to the covering mode common to the standard type of Dvaravati, often leaves the right shoulder bare. In

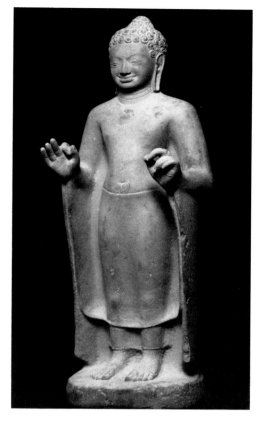

29

BUDDHA

Cambodia, Angkor Borei; 7th century
Sandstone
25 in (63.5 cm)
D. A. Latchford collection

opposite

28

HEAD OF A BUDDHA

Cambodia, style of Angkor Borei; 6th century
Sandstone
23 in (58.4 cm)
Private collection

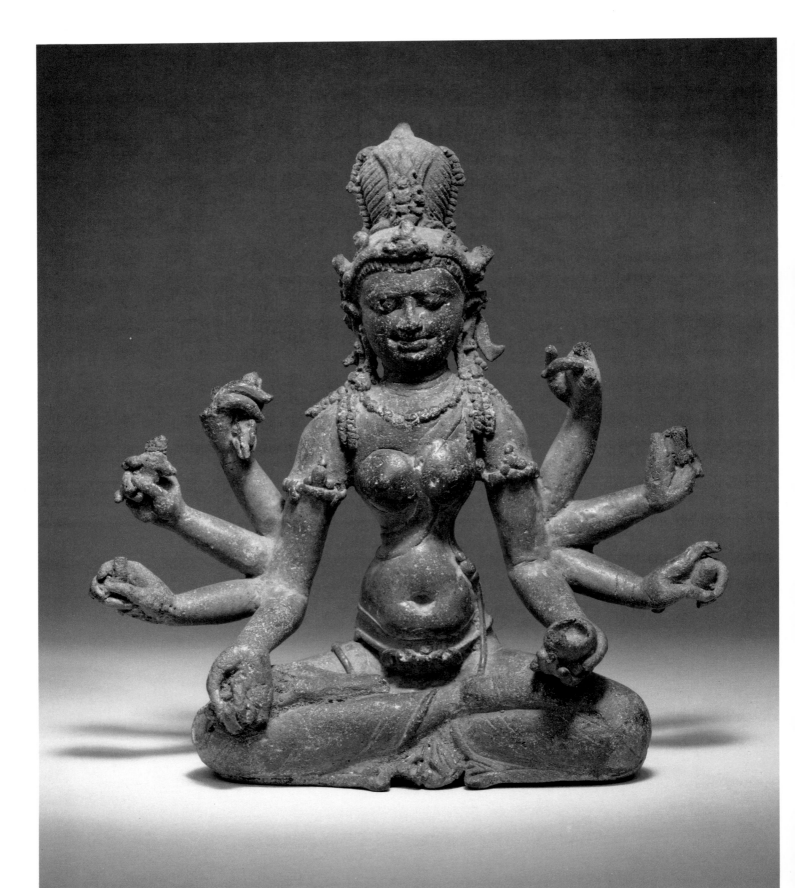

some cases, the right hand may extend downwards in the gesture of benediction (see [33]). When seated, the pose is usually heroic, while the hands rest on the lap in the gesture of meditation, recalling the iconic formula of the southern schools of the Indian subcontinent, which also appeared in early images of the Buddha in other styles of Southeast Asia. When the figure is seated in the European pose, the attitudes of the hands are apparently similar to those encountered in the Dvaravati style: the right hand is raised in the gesture of elucidation, while the left hand is held suspended at a certain level above the knee.

Bodhisattva images first appeared in Cambodia proper around the seventh century, about the same time as in Burma, central Thailand, and the peninsula. Most of them can be identified as Avalokiteshvara and Maitreya, who are mentioned in a triad in association with the Buddha in an inscription of the seventh or eighth century from Prasat Ampil Rolum.[81] Avalokiteshvara appears to have been the most popular bodhisattva: he was occasionally invoked as an independent and powerful deity, and representations of him in stone and bronze are frequently found in the art of the pre-Angkor period. Epigraphical references to Maitreya are very scarce. He seems to have been mentioned only once in pre-Angkor period inscriptions, although there are many images of him from this period. A Buddhist goddess, Vidyadharani, invoked in an inscription of 693 c.e.,[82] may have been the same as Prajnaparamita, the Buddhist personification of supreme knowledge and wisdom. Representations of Prajnaparamita in the art of pre-Angkor Cambodia have not yet been identified with certainty,[83] but many of them existed in the art of neighboring Champa in the ninth century.[84] Two examples also occur among the ninth-century statuettes found at Khon Buri in northeastern Thailand, which were made under the strong artistic influence of Cambodia.[85] The cult of Prajnaparamita became more prominent in Cambodia during the tenth century and beyond; she was apparently venerated as a consort of Avalokiteshvara, and also as a powerful goddess who manifested herself in many forms and played many different roles in the Buddhist pantheon.[86]

30

BUDDHIST GODDESS

Indonesia, Java; Central Javanese period, 8th century
Bronze
6 ¼ in (15.9 cm)
The Asia Society,
The Mr. and Mrs. John D. Rockefeller 3rd Collection

The region of Angkor Borei produced a number of bodhisattva images, some of which are among the earliest known in Cambodia. Others came from Ak Yom near Prei Kmeng, and more examples of a later date have been assembled from many parts of the country. Materials for the study of Cambodian Buddhist sculptures are greatly augmented by the bronze finds at Prakhon Chai, Lam Plai Mat, and Ban Tanot in eastern Thailand, which were under a strong cultural influence from Cambodia.[87] There must have been substantial Buddhist communities in that region, practicing a religion that was a minor cult in Cambodia proper but which produced a large quantity of images in a style that can be viewed as a prolongation of that of Ak Yom in Cambodia.

The stylistic evolution of bodhisattva images from Cambodia, as well as of the affiliated bronze finds from eastern Thailand, followed the same course of development as shown by Hindu images, which constitute the majority of sculptural remains from ancient Cambodia. The process of development and the chronological sequence of Cambodian art worked out in great detail by French scholars[88] still remain a firm basis for the study of sculptures depicting Buddhist themes.

In the earliest images of the late seventh century, unanimously classified as being of the style of Prei Kmeng,[89] the classical norm laid down by the Indian Gupta style is clearly manifest in the slim and elegant body and in the clarity and sophisticated simplicity of lines, very much as in the oldest bodhisattva figures from peninsular Thailand. The mode of depicting Avalokiteshvara and Maitreya in purely ascetic attire and the systematic arrangement of the hair also reflect the Gupta tradition. The Cambodian style nevertheless developed quickly, and indigenous features had begun to assert themselves already in the earliest configurations of these Buddhist deities, in an un-Indian physiognomy and the local style of dress. There was also a preference for depicting the figures with four arms, a feature that is commonly attributed to Avalokiteshvara in Indian iconography but is practically unknown in Indian representations of Maitreya.

The elegant plastic form of the seventh century began to be simplified and formalized in the styles of Prasat Andet and Kampong Preah in the eighth century.[90] The contours became hardened and the posture static, and yet many pieces retained a high degree of proud dignity, vitality, and grace. Schematization of the body, limbs, and patterns of hair and garment folds became conspicuous by the end of that century and was carried on into the ninth century.[91]

In the course of the eighth century, there seems to have been a renewed interest in the idealized figure type of the early seventh century and a fuller and slightly muscular form infused with a monumental dignity occasionally appeared,[92] but a rigid frontal

pose was now usually preferred to the slightly flexed pose of the past.[93] The preference for this figure type continued into the ninth century, when it quickly faded away. There are also some indications of stylistic influences from Champa and maritime Southeast Asia during the eighth and the ninth centuries,[94] but bodhisattva images, on the whole, developed following the main trend of stylistic evolution that culminated in the highly formalized style of Prah Ko and set the standard for the art of Angkor in the age to come.

CHAMPA

Many settlements enriched by trade grew up in the coastal areas of Champa at the dawn of the Common Era. Chinese records mention an important kingdom called Linyi, the founding of which is said to go back to the second century C.E. Local inscriptions written in Sanskrit and native Cham attest to the prevalence of Indian culture and Indian-style kingship by the fourth century.[95] There must have been more centers or principalities, which rose up and competed with one another for political supremacy from the very beginning. Many such states, known to the Chinese by different names during the seventh to ninth centuries, would have existed in proximity to one another, fighting, making allies, and establishing hegemony in turn. The earliest political and cultural center was situated to the north of present-day Hue, in the northern province of Amaravati. By the eighth century, the hegemony began to shift to the south, to Kauthara (modern Nha Trang) and Panduranga (modern Phan Rang). The northern province once more became the center of political eminence during the last quarter of the ninth century, and remained so until the end of the tenth century.

Only a few artifacts from the historical period predate the seventh century. These include some stone and terra-cotta reliefs which once were parts of religious buildings,[96] and a fragment of a bronze Buddha image showing a strong influence of the classical Gupta style of India.[97] These finds may also be regarded as the earliest known evidence of Indian cultural influence upon the indigenous art tradition, which apparently used perishable materials.

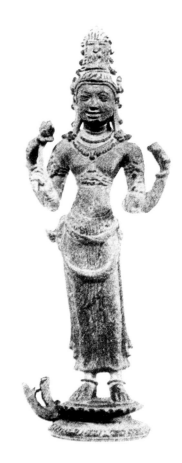

3 I

A V A L O K I T E S H V A R A

Vietnam, Quang-tri, Thu'y-cam; mid-9th century
Bronze
National History Museum, Ho Chi Minh City
Copied from Boisselier 1963, fig. 37

The first substantial remains of Cham religious art date from the middle of the seventh century. These were parts of a grand monument at Mi-son, the great temple city and the most important ritual center of the Chams.[98] The earliest sculpture style of Champa, known as the style of Mi-son EI, shows a strong influence of Indian art of the post-Gupta period, especially the Chalukya style of southwest India, but at the same time reveals a close relationship with the contemporary Prei Kmeng style of Cambodia, although it seems far superior to that style in sophistication and originality.[99] A high degree of sensitivity and almost uncontrolled vigor and exuberance distinguish many relief sculptures of the beginning of the eighth century.[100] However, formal images of divinities made during the same period look stiff and conventionalized, recalling the last stage in the development of icon sculpture in pre-Angkor Cambodia. Cham ethnic features, characterized by everted lips emphasized by ponderous mustaches, heavy-lidded eyes, and thick, slanting joined eyebrows, became most conspicuous in the style of Dong-duong in the late ninth century.[101]

Situated as they were along the coastal line, the Cham kingdoms remained more susceptible to external influences than Cambodia. Besides the strong influences of the Chalukya style in the seventh century, the impact of the Pallava tradition of southeast India is also discernible in Cham sculptures of the late seventh and eighth centuries.[102] This was followed by influences from medieval northeastern India, which may have arrived through the Indonesian archipelago.[103] Sculptures of the ninth-century style of Hoa-lai in the southern province of Champa exhibit many stylistic details similar to those that appeared in Java during the eighth and ninth centuries,[104] and certain elements of Dvaravati have also been noticed in some Buddhist sculptures of Champa of the same period;[105] there must have been regular traffic between the southern coast of Champa and cities on the Gulf of Thailand in those times. In addition, the influence of Chinese art—rarely discernible in other traditions of Southeast Asia—is clearly seen in the style of the late ninth century, and this became even stronger after the end of the tenth century.

Although Hinduism was the predominant religion of the Cham kings, Buddhism was also practiced in the Cham country from very early times. Chinese accounts mention a large-scale plundering of Buddhist monasteries in 605 C.E., and give an impression of these being rich establishments equipped with large libraries.[106] Yizing, the conscientious pilgrim who kept records of Buddhist practices in southern and Southeast Asia in the seventh century, also referred to Buddhist communities in Champa.

The practice of Buddhism in Champa was obviously reinforced by the impact of Mahayana Buddhism, which reached Southeast Asia during the seventh century. Nevertheless, Buddhism remained a minor religion until late in the ninth century and

early in the tenth century, when the kings of the Indrapura dynasty built splendid and extensive monasteries and dedicated them to Avalokiteshvara, the most powerful bodhisattva in the Buddhist pantheon. Even then, Shiva remained the unrivaled tutelary god of Champa, and was invoked in royal inscriptions side by side with the Buddha and Avalokiteshvara.[107]

The oldest Buddha image known from Champa is a damaged bronze from Na-khe, which may date from the sixth century.[108] The style and treatment of this bronze recall the classical Gupta tradition of India. No material evidence found so far suggests that Champa was in contact with the bastions of Theravada Buddhism in southern India or Sri Lanka prior to the seventh century; the famous Buddha of Dong-duong, once considered among the earliest evidence of Southeast Asia's contact with the southern regions of the Indian subcontinent, apparently dates from this time or even later.[109] Some other Buddha images in bronze display iconographic and stylistic affinities to eighth-century products of the Dvaravati style in central Thailand,[110] while a few others reveal elements of the early medieval style of northeastern India in the treatment of the robe and in the form and decorations of the throne for a seated figure.[111] This last category of stylistic elements may have reached Champa through Java; there are records of military and cultural contacts between the two areas in the eighth and tenth centuries.

The large stone Buddha image and its associated sculptures from the great hall of the Lakshmindralokeshvara monastery at Dong-duong[112] display a soft and rounded figure type like that in vogue in the ninth-century styles of northeastern India and Java. This is generally shown in combination with a ponderous massiveness, great vitality, and emphatically indigenous physiognomical traits. Elements of Chinese art, which may have reached Champa through Sinicized Annam, are discernible in the pagoda-like form of the stupas standing in the compound and in the treatment of the robe worn by the Buddha and monk figures, in which the tail end of the garment passes over and covers a part of the right shoulder.

Bodhisattva images constitute the largest percentage of

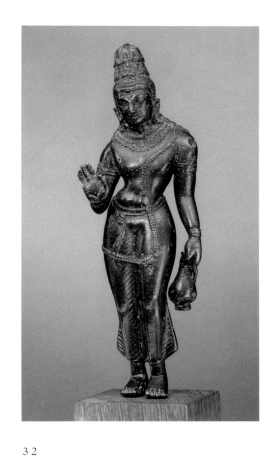

32

AVALOKITESHVARA

Southeast Asia; 8th century
Bronze
4 ⅝ in (11.7 cm)
The Asia Society,
The Mr. and Mrs. John D. Rockefeller 3rd Collection

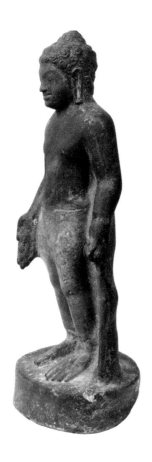

33

SHAKYAMUNI

Cambodia; 7th century
Sandstone
19 ¼ in (49.0 cm)
Doris Wiener collection

Buddhist sculptures in Champa; the time span of their production extended from the late seventh century to the early years of the tenth century. As in other parts of Southeast Asia, Avalokiteshvara appears to have been the most prominent of all Buddhist deities. He was worshiped independently as the personal deity of the kings of the Indrapura dynasty, and also occupied an exalted position in the supreme Buddhist triad in association with the Buddha and Vajrapani. Images of Avalokiteshvara in stone and in bronze appear in many different forms, ascetic as well as princely, and equipped with a variant number of arms, ranging from two to eight.[113] A miniature Buddha in the headdress is his most characteristic mark. A fragmentary bronze image found at Dai Hu'u[114] may represent the bodhisattva Vajrapani, who is referred to in an inscription as the counterpart of Avalokiteshvara in a triad. No epigraphical references to Maitreya are known from Champa, and none of the icon sculptures can be identified with certainty as representing Maitreya. A relief at Dong-duong shows the Buddha-to-be in Tushita Heaven.[115] Standing by itself, this scene could possibly represent Maitreya enthroned in his celestial abode. In this case, however, the relief forms part of a series narrating the life history of the historical Buddha, and was probably meant to represent Shakyamuni in his pre-Buddha stage being requested by the gods to assume his last birth on earth.

The goddess of supreme wisdom, Prajnaparamita, invoked in a few inscriptions of the ninth and tenth centuries, is represented in a number of stone images made in the style of that period.[116] She appears to have been venerated as the consort of Avalokiteshvara, bearing upon her headdress a similar mark of cognizance, namely a miniature image of the celestial Buddha Amitabha.

Formal images of bodhisattvas and Prajnaparamita tended to assume a frontal posture and hieratic rigidity characteristic of such sculpture in Champa from the earliest period. This feature is most apparent in stone images, which undoubtedly occupied important positions in the temples. Bronze bodhisattva figures form quite a distinctive type,[117] remarkable for a slender and elongated body matched by a tall, cylindrical mass of hair. Usually representing Avalokiteshvara, these figures are clad in a

special type of attire, which reveals new stylistic inspirations from the Pallava and Chalukya regions of southern India.[118] The early examples show a supple form and gentle modeling, but the body and stance soon became rigid, and the figures assumed a severe hieratic look typical of Cham icons. This mode of depiction apparently extended its influence into peninsular Thailand during the eighth and ninth centuries. An image of this type was apparently introduced into Yunnan, and this became the model for the standard depictions there of Avalokiteshvara, who was worshiped as the dynastic god of the Tali kingdom in the twelfth century.[119]

Softer and fuller forms accompanied by a graceful pose and a more supple arrangement of limbs appeared in Cham sculpture in the Dong-duong style of the late ninth and early tenth centuries. This figure type is also encountered in stone images representing Avalokiteshvara and Prajnaparamita.[120] But in sculptures that were meant to serve as icons at shrines, the form became much more stylized and simplified. The Buddhist savior and his consort, bearing pronounced traits of Cham physiognomy, stand in a stiff frontal pose in a frozen hieratic immobility typical of the Cham icons. The figurative forms show a tendency to lose their naturalistic features and seem to disappear into a cubical outline common to indigenous stone slabs, which are relics of the Chams' megalithic past and reflections of their ever-present ancestor worship.[121]

CONCLUSION

Southeast Asia presents a mosaic of art styles which, in spite of their shared aesthetics and common heritage, are quite variant in expression and trend of development. Stylistic studies of art objects reveal a more and more amazing pattern of cultural exchanges and interrelations among the communities. The Prakhon Chai bronzes that form the main feature of this exhibition occupy a special place within the artistic framework of the entire region. They represent an unusually large and homogenous group of sculptures, which attests to a long history of development of a remarkable artistic tradition that existed in the shadow of pre-Angkor Cambodia and drew some inspiration from the Dvaravati of Thailand but, at the same time, expressed its own religious sentiments in a most explicit way. Moreover, the bodhisattva images from Prakhon Chai and its related sites are among the earliest Mahayana-oriented sculptures found in Southeast Asia, and many can undoubtedly be counted among the most aesthetically successful configurations of divine personages ever conceived and created by humanity.

NOTES

1. For this see also Bandaranayake et al. 1990.

2. Among the most recent works and surveys on the subject are: *SPAFA Final Report* 1985, 113-30; Bronson 1986, 213-29; Glover 1989; Stargardt 1990, 150, 174; Higham 1989, 237-319.

3. Veeraprasert 1985, 168-69; Bronson 1986, 213-29; Higham 1989, 252-53.

4. See Coedès 1968, 36-64.

5. Wheatley 1979, 288-303; Wolters 1979, 427-42; Vallibhotama 1986, 229-38; Vickery 1986, 95-115; Higham 1989, 239-320.

6. Wang Gungwu 1958, 1-135; Smith 1979, 443-49; see also Woodward 1988, 75-91.

7. Soper 1949, 28-30, 34; Soper 1959, 5, 6, 80-82, 85, 106, 109.

8. See Coedès 1937-66, VOL. 4, 27; Sarkar 1971, 15-24, 41-48.

9. Aung Thaw 1968; Gutman 1978, 8-21; Mitchiner 1982, 5-12; Stargardt 1990, 173-84.

10. Duroiselle 1926-27, PL. XLI,D; Aung Thaw 1972, PLS. on 22, 26, 30, 32.

11. Aung Thaw 1972, PLS. on 29, 30; Snellgrove 1978, PL. 100.

12. Duroiselle 1909-10, PL. XLVIII; Aung Thaw 1972, PL. on 29; Snellgrove 1978, PL. 100.

13. Aung Thaw 1972, PLS. on 22-25.

14. Aung Thaw 1972, PLS. on 29, 30; Snellgrove 1978, PL. 100.

15. Duroiselle 1926-27, PL. XXXVIII,D.

16. Ray 1936, 42-43.

17. Luce 1969-70, VOL. 1, 193.

18. Chutiwongs 1984, PL. 29.

19. Duroiselle 1926-27, PL. XLII,A,C; Duroiselle 1927-28, PL. LV,2,8.

20. Duroiselle 1927-28, PL. LV,3; Chutiwongs 1984, 97.

21. Duroiselle 1927-28, 130, PL. IV,2; U Mya 1961, PT. 2, FIG. 16; Chutiwongs 1984, 126.

22. Luce 1969-70, VOL. 3, PLS. 444A,B, 444E,F; Lowry 1974, FIG. 18; Chutiwongs 1984, 167-68, PLS. 32, 33; Zwalf 1985, 161, NO. 221.

23. Luce 1969-70, VOL. 3, PLS. 55A-E; Chutiwongs 1984, 123, PLS. 31-33.

24. Chutiwongs 1984, 123-25.

25. See note 15.

26. Frédéric 1964, PLS. 9, 11.

27. Duroiselle 1936-37, PLS. XXXI,B,C, XXXII,A-C, XXXIII,A; Frédéric 1964, PL. 18.

28. Aung Thaw 1972, PL. on 30.

29. Bronson 1979, 315-36; Higham 1989, 270-79.

30. Boisselier 1968, 29; Boisselier 1969, 48-50; Boisselier 1972, 27-45; Loofs 1979, 342-51.

31. Quaritch Wales 1969, 10-11, PLS. 3A and 4; Charoenwongsa and Diskul 1976, 87, PLS. 5, 6; Lyons 1979, 352-59.

32. See Chutiwongs 1984, 212, N. 2.

33. *Ancient Inscriptions from Lopburi* 1981; Bauer 1991, 34.

34. Chutiwongs 1984, 212; Higham 1989, 271.

35. Dupont 1959.

36. Quaritch Wales 1969; Boisselier 1972, 27-45.

37. Griswold 1960, 41-44.

38. Bowie, Diskul, and Griswold 1972, PLS. 2, 3, 13; Chutiwongs 1984, PL. 61.

39. Chutiwongs 1984, PLS. 62-78.

40. Quaritch Wales 1969, 81-85; Boisselier and Beurdeley 1974, 104-6; *Inscriptions from Si Thep* 1991.

41. Quaritch Wales 1969, PLS. 50-51.

42. Bowie, Diskul, and Griswold 1972, PL. 7,A,B; Chutiwongs 1984, 221, N. 143, PL. 72.

43. Coedès 1968, 68-70; *Silpakon* 32(6) 1989.

44. Boisselier and Beurdeley 1974, 107-14; Diskul 1979A, 14-16; *Silpakon* 32(6) 1989.

45. Quaritch Wales 1969, 282-83; Krairiksh 1974, 35-65.

46. Khwanyun 1980, 71-84.

47. Diskul 1979B, 360-70.

48. Bunker 1971-72, 67-76.

49. *Masterpieces of Bronze Sculpture from Ban Fai* 1973.

50. Boisselier 1967, 284-310; Boisselier and Beurdeley 1974, 107-14.

51. Bunker 1971-72, FIG. 20.

52. Bunker 1971-72, FIGS. 9, 14, 27.

53. Viriyabus 1974, 195-200.

54. Boisselier 1967; Bunker 1971-72; Le Bonheur 1972; *Masterpieces of Bronze Sculpture from Ban Fai 1973*.

55. Quaritch Wales 1969, 88-93; *Guide to National Museum Prachin Buri 1985*; *Silpakon 32(6) 1989*; Woodward 1983, 379-80.

56. Boisselier and Beurdeley 1974, 93-103; Diskul 1980C.

57. O'Connor 1972, 19-26, FIGS. 1-3; Krairiksh 1980, NOS. 1-3.

58. Chhabra 1965, 40-57, 85-97; De Casparis 1975, 14-18.

59. Pachow 1958, 13; Soper 1959, 10, N. 15.

60. Chhabra 1965, 18-21; De Casparis 1975, 19-20.

61. Diskul 1980B, PLS. 1, 3, 6, 9, 11-15; Krairiksh 1980, NOS. 4, 5, 9, 17-24.

62. Fontein 1990, NO. 36; Fontein, Soekmono, and Suleiman 1971, NO. 22.

63. Soekmono 1979, 457-72.

64. Krairiksh 1980, NOS. 17, 19.

65. Fontein, Soekmono, and Suleiman 1971, NO. 23; Lunsingh Scheurleer and Klokke 1988, NOS. 4, 55.

66. Quaritch Wales 1976, PLS. 2A, 2B; Griswold 1966, PLS. 1, 22; Krairiksh 1980, NOS. 4, 5.

67. See Fontein, Soekmono, and Suleiman 1971, NO. 36.

68. Fontein 1990, NO. 39.

69. Diskul 1980B, PL. 3; Krairiksh 1980, NO. 18.

70. Diskul 1980B, PL. 4.

71. Suleiman 1981, cover and PL. 1B.

72. Chutiwongs 1984, 75-94, PLS. 21-27; see also Von Schroeder 1990, PLS. 59-61.

73. Woodward 1983, 381; Chutiwongs 1986, 68-82.

74. Quaritch Wales 1976, PL. 6,A,B.

75. Diskul 1980A, 1-4; Krairiksh 1980, NOS. 38, 40.

76. Bénisti 1970.

77. Boisselier 1968, PL. XLI,1.

78. Dupont 1955, 150-55; Groslier 1962, 71-76.

79. Boisselier 1955, PLS. 86-88A, 89B.

80. Dupont 1955, PLS. XLIV,A,B, XLV,B, XLVI,A-C; Boisselier 1955, PLS. 88, 89B, 90; Boissellier 1968, PLS. XL,4, XLI,2.

81. Coedès 1937-66, VOL. 6, 100-106.

82. Coedès 1937-66, VOL. 2, 85-86.

83. Chutiwongs 1984, 308, N. 40.

84. Boisselier 1963, 130-34, FIGS. 64, 67, 68.

85. Viriyabus 1974, 195-200, FIGS. 3 and 4, 5 and 6.

86. Chutiwongs 1984, 332-33.

87. See notes 48-50.

88. De Coral Rémusat 1951; Dupont 1955; Boisselier 1955; Boisselier 1968.

89. Dupont 1955, PLS. XXII,A,B, XXVIII,A, XXIX,B, XXX,A,B.

90. Chutiwongs 1984, PLS. 107-14.

91. Chutiwongs 1984, PLS. 115-16; Le Bonheur 1972, 129-54.

92. Dupont 1955, 52-55, PL. XII,B; Chutiwongs 1984, 378, PL. 109.

93. Chutiwongs 1984, PLS. 111-12.

94. Chutiwongs 1984, 378, PL. 108.

95. Coedès 1968, 47-50.

96. Boisselier 1963, 27-32, FIGS. 2-8.

97. Boisselier 1963, 27, FIG. 2.

98. Groslier 1962, 82-83, PL. on 84; Boisselier 1963, 40-45, FIGS. 10-12.

99. See also Groslier 1962, 82.

100. Boisselier 1963, 49-53, FIGS. 15-18.

101. Boisselier 1963, FIGS. 47-65.

102. Chutiwongs 1984, 453-54.

103. Chutiwongs 1984, 454-56.

104. Boisselier 1963, 84-85, FIGS. 42-43.

105. Dupont 1955, 260.

106. Maspero 1928, 82-85.

107. Chutiwongs 1984, 426-27; Mabbett 1986, 299-300.

108. Boisselier 1963, FIG. 2.

109. Barrett 1954, 51-52.

110. Boisselier 1963, FIGS. 28-29.

111. Boisselier 1963, FIGS. 30, 71.

112. Boisselier 1963, FIGS. 44-46, 50; Groslier 1962, PL. on 139.

113. Chutiwongs 1984, PLS. 172-77.

114. Boisselier 1963, 135.

115. Boisselier 1963, III, FIG. 59.

116. Boisselier 1963, 130-34, FIGS. 64, 67, 68.

117. Boisselier 1963, FIGS. 64, 67, 68, 70, 73, 74; Chutiwongs 1984, PLS. 162, 163, 165, 171-75.

118. Chutiwongs 1984, 446-47, 451.

119. Chutiwongs 1984, 477-93, PL. 179.

120. Boisselier 1963, FIGS. 64, 67, 68, 70, 73, 74.

121. For these slabs see Boisselier 1963, FIGS. 244-47.

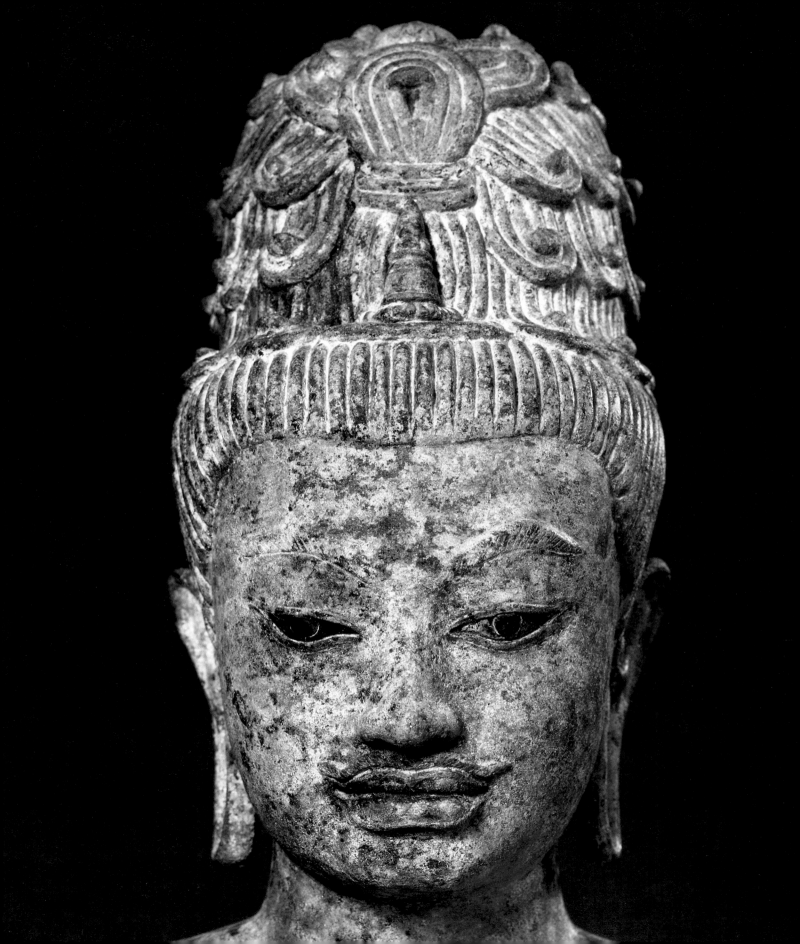

BODHISATTVA MAITREYA, PRAKHON CHAI, AND THE PRACTICE OF BUDDHISM IN SOUTHEAST ASIA

Denise Patry Leidy

The Bodhisattva Maitreya is one of the most important deities in the iconography of Prakhon Chai and related sites.[1] Representations of Maitreya and of the Bodhisattva Avalokiteshvara are the most prominent images at Prakhon Chai, and depictions of these two bodhisattvas far outnumber other types of Buddhist images from this part of Thailand. Other images from Prakhon Chai include standing Buddhas similar to the well-known Dvaravati-style works produced in other areas of Thailand and more unusual works such as seated figures of Buddhist ascetics (see [49]) or a representation of an early ruler in the guise of the Bodhisattva Avalokiteshvara [23]. Both two-armed [15, 17] and four-armed [18, 34] images of Maitreya and Avalokiteshvara were produced at Prakhon Chai and related sites. In every example, Maitreya is identified by the image of a small stupa (a bell-shaped mound or a tower used to mark the location of relics) in his headdress, while Avalokiteshvara is identified by the presence of a seated

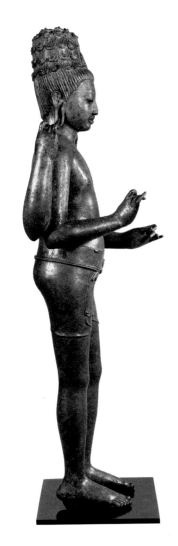

above and page 64 (detail)

see also pages 1 – 9

34

MAITREYA

Thailand, excavated at Prakhon Chai;
8th century
Bronze with inlays of silver and black stone
38 in (96.5 cm)
The Asia Society,
The Mr. and Mrs. John D. Rockefeller 3rd Collection

image of a Buddha in his headdress. The use of these particular attributes to identify Maitreya and Avalokiteshvara became common in India during the fifth and sixth centuries and quickly spread throughout Southeast Asia. The scanty clothing, long matted hair, and lack of jewelry that are characteristic of representations of Maitreya and Avalokiteshvara from this site indicate that these images are bodhisattva ascetics. This interest in depicting bodhisattvas as ascetics links the art of Prakhon Chai with imagery found throughout South Asia from the seventh through the ninth centuries.

The prominence awarded to Maitreya, however, appears distinctive to art made in the area around Prakhon Chai in Buriram Province in northeast Thailand. In addition to the more well-known sculptures excavated from sites such as Prakhon Chai and Ban Fai in Buriram Province, a few other early representations of Maitreya, such as a standing bodhisattva, in the collection of the Philadelphia Museum of Art [35], are known. As is discussed in the first essay in this catalogue, art from this part of Thailand has often been classified as pre-Angkor, because of the stylistic parallels between the material from northeast Thailand and early Cambodian works that predate the foundation in 802 of the great Khmer dynasty that ruled over parts of present-day Thailand and Cambodia until the fifteenth centuries. An understanding of the position of the Prakhon Chai and other pre-Angkor Maitreya images both within the history of Buddhist art and ideas and in relation to contemporaneous Buddhist imagery in Southeast Asia provides another dimension to existing knowledge about the development, during a crucial period, of Buddhist thought in Southeast Asia; it also helps to define the relationship of Southeast Asian practices and beliefs to those of the broader pan-Asian Buddhist community.

EARLY MAITREYA IMAGERY

Worshiped both as a bodhisattva during the present eon and as the Buddha of a future age, Maitreya, whose name means "benevolent" or "friendly," is one of the earliest and most complex deities of the Buddhist pantheon; the development of the

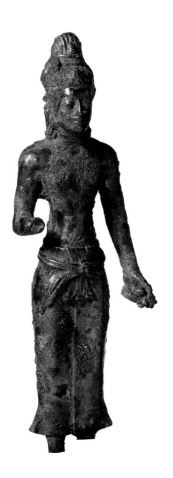 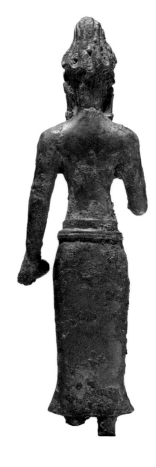

3 5

MAITREYA

Thailand, from vicinity of Chaiyafum; 8th century
Bronze
7 ¾ in (19.7 cm)
Philadelphia Museum of Art, Given by R. Hatfield Ellsworth

concept of this bodhisattva and of his imagery was part of a series of changes in Buddhism that led to the development of the Mahayana branch of this religion.[2] The belief in multiple Buddhas of the past, present, and future ages and the worship of bodhisattvas such as Maitreya and Avalokiteshvara are among the main elements that distinguish Mahayana from the earlier, more austere sects, which are known as Theravada Buddhism. Enlightened beings, bodhisattvas have chosen to remain accessible to the devout, helping to guide them on the road to spiritual perfection. The development of the cult of bodhisattvas is often linked to the predominance of foreign (particularly Near Eastern and Central Asian) influences in northwest India under the rule of the Kushana emperors (about the first to the third century C.E.), who were of Central Asian descent.[3]

Images of Maitreya, both as a Buddha and as a bodhisattva, were among the first anthropomorphic representations of Buddhist deities produced in India.[4] Numerous examples have been found in the region of Gandhara (in present-day Pakistan) and in

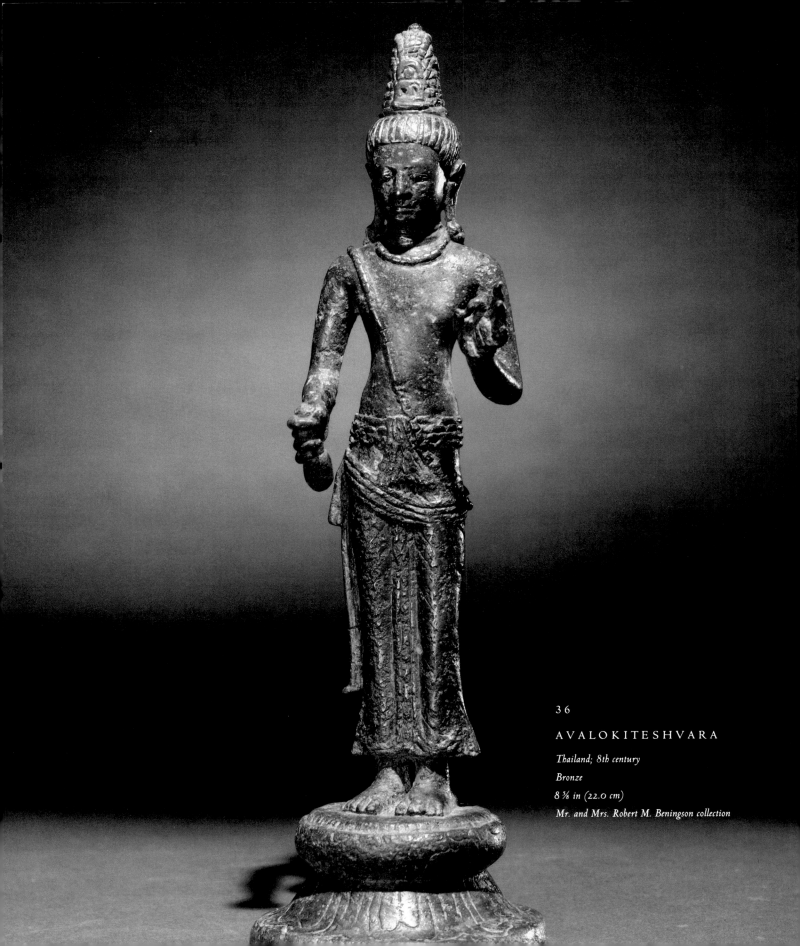

36

AVALOKITESHVARA

Thailand; 8th century
Bronze
8 ⅜ in (22.0 cm)
Mr. and Mrs. Robert M. Beningson collection

the city of Mathura (in north central India), the two main centers of the Kushana dynasty that are associated with the some of the earliest iconic Buddhist art. As a Buddha, Maitreya wears monastic robes and has the snail-shell curls, protuberance on the top of his head (*ushnisha*), and other physical characteristics that are marks of a perfected being. Images of the Buddha Maitreya are usually identified through their iconographic context: Maitreya is generally shown either together with Shakyamuni (the Buddha of the present and the historical founder of the religion) or as part of a group of deities that includes Shakyamuni and several of his predecessors.[5]

As a bodhisattva, Maitreya is depicted both as an attendant figure to the Buddha Shakyamuni and as an independent deity. The skirtlike dhoti, long scarves, and full jewelry worn by a second- or third-century sculpture of Maitreya [38] typify bodhisattva images produced in India during the Kushana period. These princely garments help to distinguish images of bodhisattvas from those of monklike Buddhas. The long matted hair of this figure, however, further distinguishes him as an ascetic. It is also a reference to his position as a member of the Brahmin caste in India and to his role as a practitioner of the priestly rituals that were the responsibility of the members of that caste. (The creation of a Brahmin background for Maitreya may be understood as part of the interplay between Buddhism and Hinduism that marks religious thought in India.) The matted hair, used as a symbol of asceticism in many contexts, may also illustrate Maitreya's personal quest for enlightenment, in which he renounces worldly pleasures to follow a spiritual quest. Such renunciation and practice led to the enlightenment of Shakyamuni, and the parallel between Shakyamuni and Maitreya reiterates Maitreya's position as Shakyamuni's spiritual successor.

Both the visual arts and Buddhist literature indicate that the cult of Maitreya first became prominent in the Gandhara region on India's northwest frontier. Images of the Bodhisattva Maitreya, such as that in [38], are more common in the art of Gandhara than in contemporaneous works from Mathura. Moreover, the development of the Maitreya cult and related visual imagery can

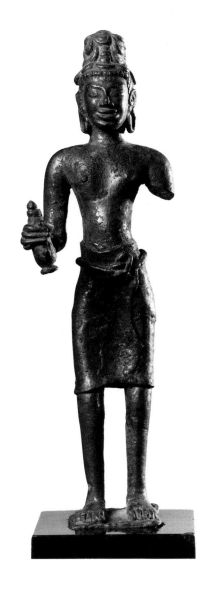

37

MAITREYA

Thailand; 7th century
Bronze
8 ½ in (21.6 cm)
The Brooklyn Museum, Gift of Mr. and
Mrs. Edward Greenberg

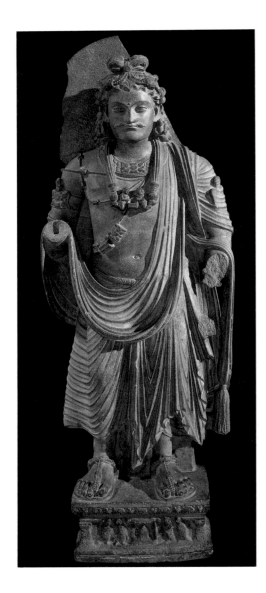

38

BODHISATTVA MAITREYA

Pakistan, Gandhara area; late 2nd century

Schist

43 in (109.5 cm)

Museum of Fine Arts, Boston, Helen and Alice Colburn Fund

be linked to the popularity of the *Mahavastu* in the Gandharan region.[6] The *Mahavastu* is the canonical text of the Mahasamghikas, a Buddhist sect influential in the northwest of India and related areas such as Kashmir and Central Asia. Compiled during the first to the fourth centuries, the *Mahavastu* developed a new interpretation of the path to Buddhahood that stresses the inherent ability of each person to become a Buddha. The *Mahavastu* was also one of the first Buddhist texts to list a group of future Buddhas beginning with Maitreya, thereby providing a framework for the worship of this deity as a Buddha and a bodhisattva.

According to the *Mahavastu*, during his spiritual career each potential Buddha passes through ten birth stages, known as *bhumis*. In the last of these stages, the Buddha-to-be resides in the Tushita Heaven to await his rebirth on earth. As the Buddha of the future (or the most imminent future), Maitreya is the most famous inhabitant of the Tushita Heaven, and is the only Buddha on the list of future Buddhas who is depicted as an independent deity in the visual arts. The worship of Maitreya as a bodhisattva on earth and as an inhabitant of the Tushita Heaven spread from northwest India throughout Central Asia to China.[7] Worship of Maitreya was particularly important in the Central Asian kingdom of Khotan. According to later Tibetan texts, Vijayasambhava and Vijayavirya, two kings who ruled Khotan in the first century C.E., are considered to have been incarnations of the Bodhisattva Maitreya.[8] Moreover, *The Book of Zambasta*, a famous Buddhist text in which Maitreya prophesies the utopia he will lead as the Buddha of the future and urges his followers to practice the proper forms of Buddhism, was written in Khotan.[9]

Images of Maitreya were very popular in Central Asian and Chinese art during the fifth and sixth centuries.[10] They are found in a number of cave-temples, such as those at Kizil, Dunhuang, and Yungang, and there are free-standing examples as well.

THE STUPA AS MAITREYA'S EMBLEM

Common in Buddhist art from the seventh century on, the use of a stupa in the headdress as a symbol for the bodhisattva Maitreya

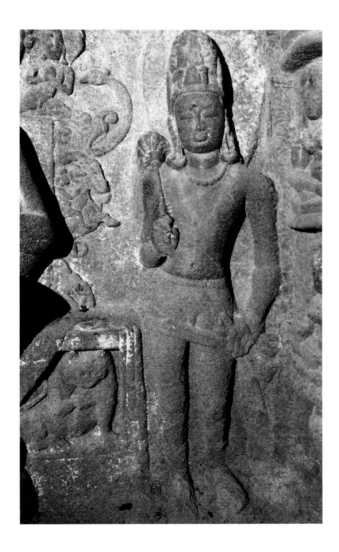

39

BODHISATTVA
MAITREYA

India, Maharashtra, Nasik, cave 23; 6th century
Stone
After Miyaji 1992, pl. 41a

is not found in the earliest images associated with this important figure. Moreover, no explanation of the rationale for the use of a stupa as Maitreya's emblem, nor any description of Maitreya with this symbol, is found in existing Buddhist texts. The earliest literary explanation of the stupa as Maitreya's emblem appears in the writings of the seventh-century Chinese pilgrim Xuan Zang.[11] According to Xuan Zang, the stupa is a reference to the rebirth of Maitreya as the Buddha of the future age. He explains that the stupa refers to an actual monument on Mount Kukkutapada near Bodhgaya in Bihar Province in eastern India. The monk Kashyapa, one of Shakyamuni's principle disciples, is buried at this site; and it is believed that when Maitreya descends to earth as the future Buddha he will travel to this mountain, which will miraculously open to

reveal the undecomposed corpse of the monk. Kashyapa will then present the garments of the Buddha Shakyamuni to Maitreya as a symbol of his position as Shakyamuni's successor.

Xuan Zang's story most likely derives from earlier writings, such as the *Divyavadana*.[12] According to this version of the story, when Maitreya travels to Mount Kukkutapada he asserts his position as Shakyamuni's successor by picking up the bones of the monk Kashyapa and holding them in his hands while preaching. Neither Xuan Zang's record nor the earlier reference to Maitreya's visit to Mount Kukkutapada provides any direct link between Kashyapa's stupa and the image in Maitreya's headdress; and it appears likely that the traditional reliance on Xuan Zang's writings to explain the use of the stupa as Maitreya's emblem may be an ex post facto explanation of a visual tradition for which no textual basis can be found. At the very least, it seems unlikely that, given their relative positions in the Buddhist view, a bodhisattva would carry the stupa of monk, however renowned, in his headdress.

An overview of the appearance and spread in the visual arts of the use of the stupa as an emblem of Maitreya as a bodhisattva, on the other hand, does suggest a possible explanation for the use of this symbol. The first consistent appearance of a stupa in Maitreya's headdress occurs in the sculptures found in several well-known cave-temples located in Maharashtra Province in northwest India. Examples, dating to the fifth and sixth centuries, are found in caves 3, 12, and 67 at Kanheri,[13] in caves 2 and 5 at Ellura,[14] in caves 17 and 26 at Ajanta,[15] in cave 23 at Nasik [39], and in cave 3 at Aurangabad.[16] In most of these examples, Maitreya is depicted as an attendant to the Buddha Shakyamuni and is readily distinguishable from the Bodhisattva Avalokiteshvara, who is identified by the small figure of a seated Buddha Amitabha in his headdress.

Iconographic changes found in the imagery of these cave-temples indicate that they were strongly influenced by the esoteric or tantric tradition, which was becoming important in Mahayana Buddhist thought during this period. Female divinities, multi-headed and multi-armed bodhisattvas, the depiction of bodhisattvas as ascetics, and

40

AVALOKITESHVARA

Thailand; 9th century

Bronze

8 ½ in (21.5 cm)

National Museum, Bangkok

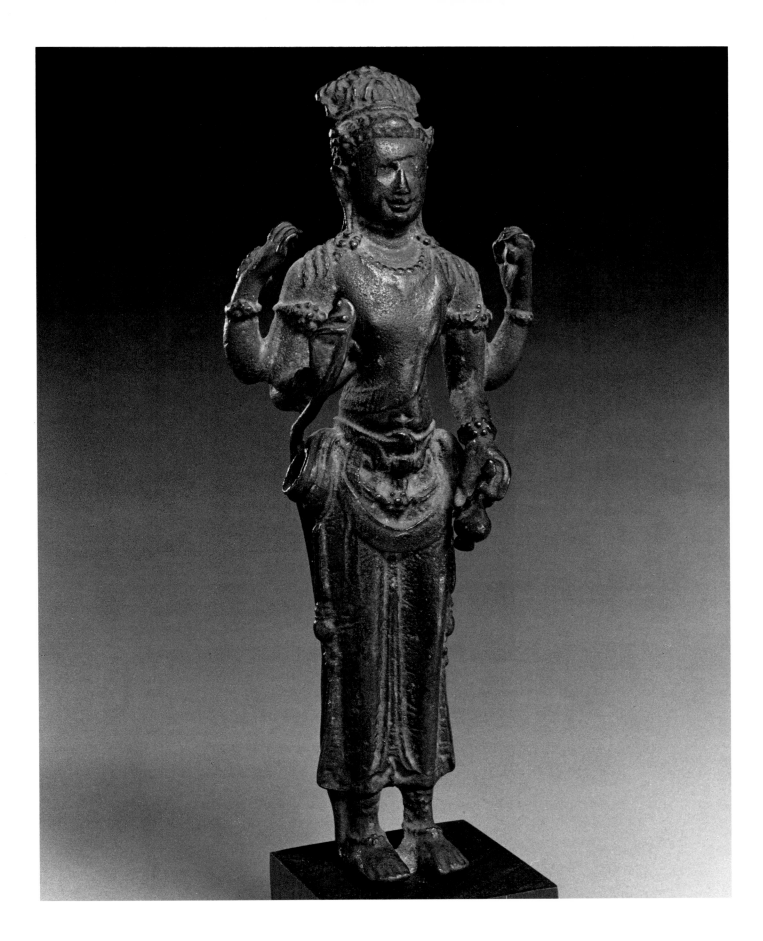

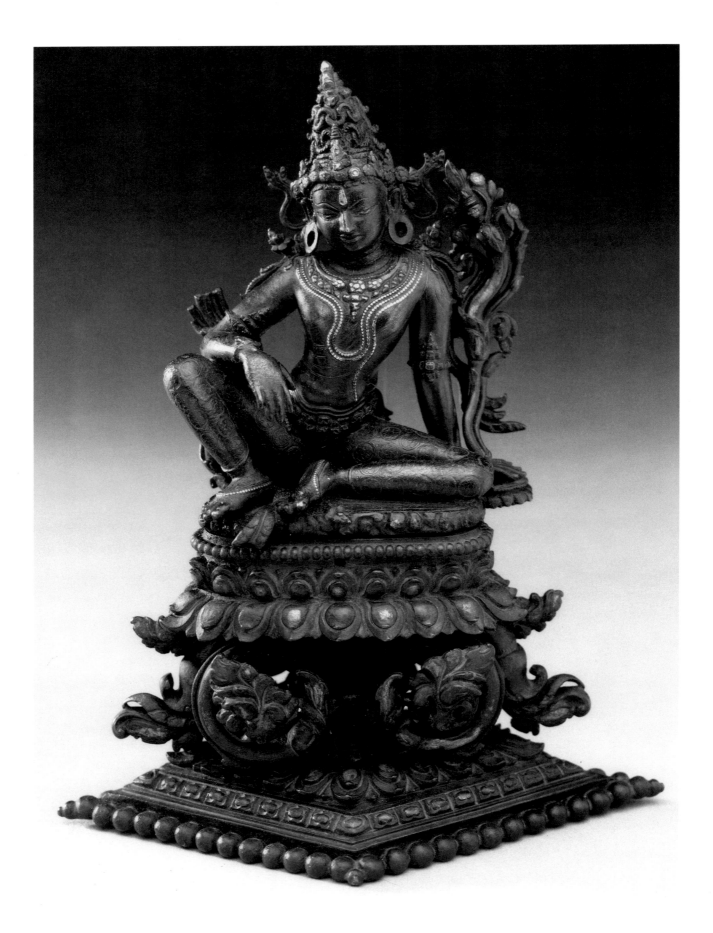

the placement of Buddhas and bodhisattvas into mandala-like arrangements also reflect the development of esoteric Buddhism. Best known in the form practiced today in Tibet and other Himalayan regions, esoteric Buddhism (also known as Tantric Buddhism or Vajrayana) is characterized by an expanded pantheon of deities, often subdivided into Buddha-families; the use of certain mental and physical exercises; the chanting of mystical sounds; and the importance awarded to rites and ceremonies in the quest for enlightenment. Many of the practices associated with this type of Buddhism can be traced to some of the earliest civilizations in India, and the precise origins of esoteric Buddhism remain controversial.[17] Nonetheless, the development of this type of Buddhism in India during the fourth through the seventh centuries and the spread of esoteric Buddhism throughout Asia, particularly from the seventh through the ninth century, are widely acknowledged. Its prominence in the eastern regions of India, particularly in Bengal and Bihar provinces during the rule of the Pala kings (eighth through twelfth centuries), and in the Buddhism practiced in Nepal and Tibet, are especially notable.

Both the appearance of the stupa as Maitreya's emblem in the iconography of cave-temples associated with the development of esoteric Buddhist imagery and the popularity of this type of Maitreya image in regions in which esoteric Buddhism was popular suggest that use of this stupa as Maitreya's symbol may illustrate esoteric beliefs and practices. Since in esoteric Buddhism the Buddhas, bodhisattvas, and other deities were often grouped into Buddha-families, each of which was headed by one particular Buddha, it is possible that the stupa in Maitreya's headdress is intended to refer to the Buddha Amoghasiddhi, who is the spiritual head of Maitreya's Buddha-family.

Often found in the headdress of the Bodhisattva Avalokiteshvara, the Buddha Amitabha is the head of Avalokiteshvara's spiritual family. Images of Avalokiteshvara bearing a seated Buddha in his headdress first appear in Indian art around the late second century, at the very end of the Kushana period.[18] Avalokiteshvara is described as having a Buddha in his headdress in the *Amitayurbuddhanusmrti sutra*, which is generally dated to about the fourth century. The first identification of this Buddha as

4 I

MAITREYA

India, possibly Bihar; about 12th century
Bronze
7 ¼ in (18.4 cm)
Mr. and Mrs. John Gilmore Ford collection

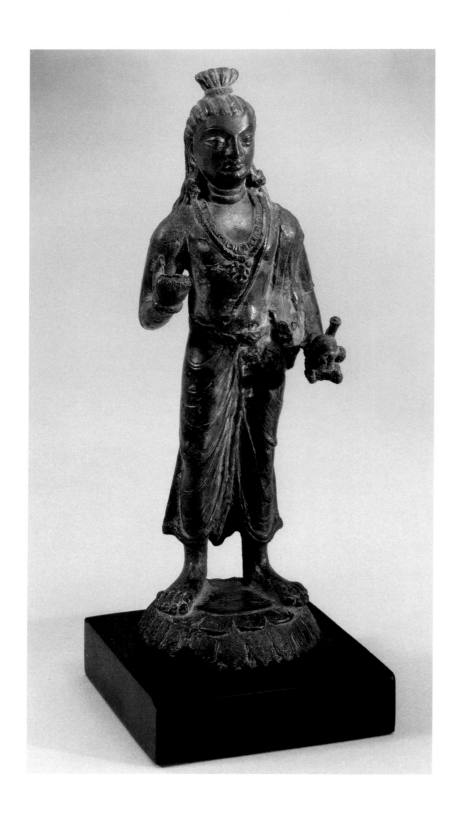

42

BODHISATTVA,
PROBABLY
MAITREYA

India, Kashmir; about 400
Bronze
10 ½ in (26.7 cm)
Los Angeles County Museum of Art, from the
Nasli and Alice Heeramaneck Collection,
Museum Associates Purchase

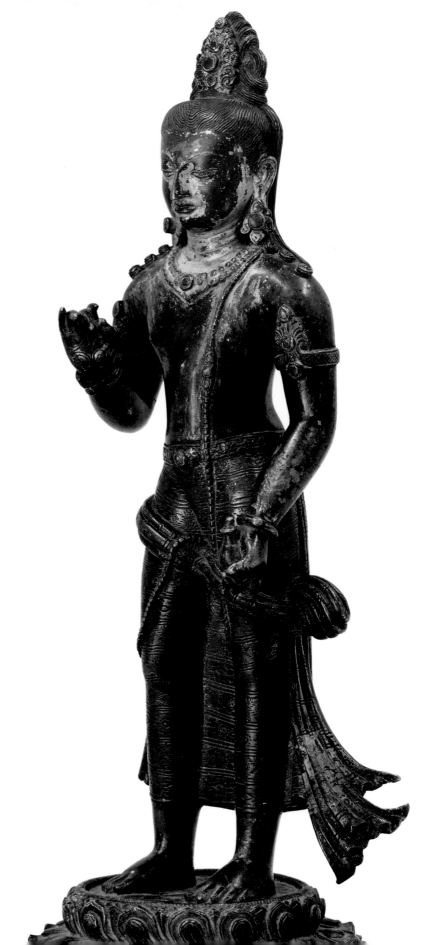

43

MAITREYA

Nepal; 11th century
Bronze
17¼ in (43.8 cm)
Los Angeles County Museum of Art,
Gift of Mr. and Mrs. J. J. Klejman

Amitabha, however, is found, once again, in the seventh-century writings of Xuan Zang.[19] Unlike the use of the stupa as a symbol for Maitreya, however, the use of Amitabha imagery in the iconography of Avalokiteshvara is provided with a textual explanation in the ninth-century *Sadhanamala*, an esoteric Buddhist text that lists the image of this Buddha as one of the principal symbols of the bodhisattva.[20] The importance of the stupa and the seated Amitabha as symbols identifying Maitreya and Avalokiteshvara, respectively, in the imagery of the fifth- and sixth-century cave-temples in Maharashtra Province provides further evidence of some of the earliest developments in esoteric Buddhist imagery.

Popular throughout the Gupta period (320-647), images of Avalokiteshvara predominate in the Maharashtra cave-temples, while those of Maitreya appear to have been less important. From the eighth through the twelfth century, Maitreya was often represented, both as a Buddha and as a bodhisattva, in the arts of Kashmir, Nepal, and eastern India; his imagery during this period reflects the evolution of Buddhist art and practices first recorded in the Maharashtra caves.

Probably made in Bihar Province in India, a twelfth-century bronze sculpture [41] exemplifies the iconography of Bodhisattva Maitreya images in Buddhist art from the eighth century on. Seated in the posture of royal ease (*maharajalilasana*), Maitreya wears the elaborate jewelry and elegant clothing of a princely bodhisattva. Nonetheless, his matted hair and the water vessel found in the petals of the white lotus (*nagakeshara*) he holds illustrate his asceticism. Use of this white lotus as an attribute of Maitreya became prominent in the art of the cave-temples in Maharashtra Province. As is the case with the use of the stupa, the precise meaning is difficult to ascertain, but it seems likely that this form of the flower was chosen as a way to further distinguish Maitreya from Avalokiteshvara, who also holds a type of lotus in his hands. The care taken to distinguish the bodhisattvas from one another and to differentiate the varying forms of any given bodhisattva also reflects the development of the extraordinarily complex pantheon worshiped in esoteric Buddhism.

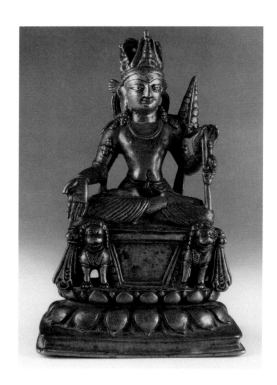

44

MAITREYA

Pakistan, Gilgit or Swat; 9th century
Brass with cold-gold painted face and silver or electrum eyes
10 in (25.1 cm)
The Nelson-Atkins Museum of Art, Kansas City, Missouri,
Purchase, Nelson Trust

There is ample evidence of the study and practice of esoteric Buddhism in Southeast Asia from the seventh through the ninth centuries. Terms used in inscriptions such as that found at Talang Tuwo in Sumatra and dated 684 C.E.[21] indicate that esoteric Buddhism was known and practiced in the kingdom of Shrivijaya, an important seafaring nation with capitals in both Sumatra and peninsular Thailand. In addition, the warning against tantric practices found in the seventh-century Telega Batu inscription from Shrivijaya suggests that different branches of esoteric Buddhism were known and practiced at that time.[22]

Sumatra was one of the most famous centers for the study of esoteric Buddhism. Patronized by the rulers of Shrivijaya, the university in Sumatra attracted scholars and monks from all over Asia. For example, the Chinese pilgrim Yijing (635-713) studied there on three different occasions in the late seventh century,[23] and such Indian masters of esoteric thought as Vajrabodhi (died 741), who visited the university in 713,[24] and Atisha (982-1042), one of the most influential figures in the development of Tibetan Buddhism,[25] are also known to have spent time there.

On the other hand, the continuing speculation over the meaning of the shape of the early ninth-century Javanese Borobudur,[26] one of the most famous monuments in Southeast Asia, illustrates the paucity of information that exists regarding the precise nature of esoteric beliefs and practices in this part of Asia. Built under the aegis of the Shailendra dynasty (founded before 778), the Borobudur was part of an enormous building boom in central Java that ended about 930 when the rulers, for reasons that remain unclear, moved their capital to the eastern part of Java. The Borobudur is composed of a large basement-level terrace, a series of five stepped terraces in the shape of articulated squares, three graduated circular rows of stupas, and a single stupa in the center of the topmost level.

This complicated structure has been the subject of much speculation, and scholars have long debated whether the Borobudur is a stupa or a mandala, or a combination of both. Mandalas are cosmological diagrams, generally filled with deities in the Buddhist

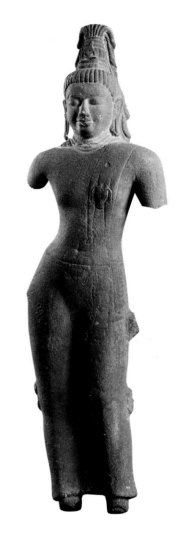

45

AVALOKITESHVARA

Thailand, found at Chaiya, Surat Thani; 7th century
Stone
45 ¼ in (115.0 cm)
National Museum, Bangkok

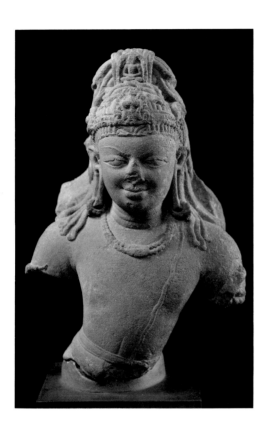

46

AVALOKITESHVARA

India, Uttar Pradesh, Sarnath region;
late 6th century
Sandstone
12 in (30.0 cm)
Museum of Fine Arts, Boston, Helen and Alice
Colburn Fund

opposite

47

MAITREYA

Thailand; 7th century
Bronze
10 ¼ in (26.0 cm)
Robert Kipniss collection

pantheon. The best-known examples of mandalas are found in Tibetan paintings dating from the fourteenth through the nineteenth centuries.[27] However, evidence for the existence of an earlier type of mandala is found in the parallels between the iconographic organization of the principal Buddhas and attendants depicted in cave 6 at Aurangabad in western India, dating to the sixth century, and that of the two mandalas used in the Japanese Shingon school of Buddhism, the earliest examples of which are generally dated to the ninth century.[28] The appearance of this type of imagery in two distant regions of Asia attests to the rapid spread and development of esoteric Buddhism during the seventh to the ninth centuries. Although the structure of the Borobudur is reminiscent of the shape of many painted mandalas, the narrative imagery found on this famous monument differs from the more iconic presentation of deities found on early mandalas.

Nonetheless, the complexity of the Borobudur, its ability to guide the viewer-practitioner through a journey that is simultaneously physical, psychological, and spiritual, and the organization of the multiple Buddhas seated in its top three tiers may link the Borobudur to other early mandalas and suggest that this monument may represent an early example of mandala imagery.[29]

The close connection between several renowned monks famous for their travels throughout Asia was one of the factors responsible for the early spread of esoteric Buddhism. Kukai, posthumously known as Kobo Daishi (774-835), was the founder of the Shingon school. He traveled to China in 804 and was initiated into the practices of the "true word"—the *chenyan* or Shingon school—by the Chinese monk Huike (died 805). Huike's teacher was the famous Amoghavajra (705-774), a Central Asian from Samarkand, who had in turn studied with the Indian master Vajrabodhi.[30] Both Vajrabodhi and his pupil Amoghavajra traveled to Southeast Asia, suggesting links between the practice of Buddhism there and slightly later traditions in China and Japan. Moreover, Vajrabodhi is known to have studied esoteric Buddhism in western India, the locus of Aurangabad and the other cave sites that have been associated with the development of esoteric Buddhist art.

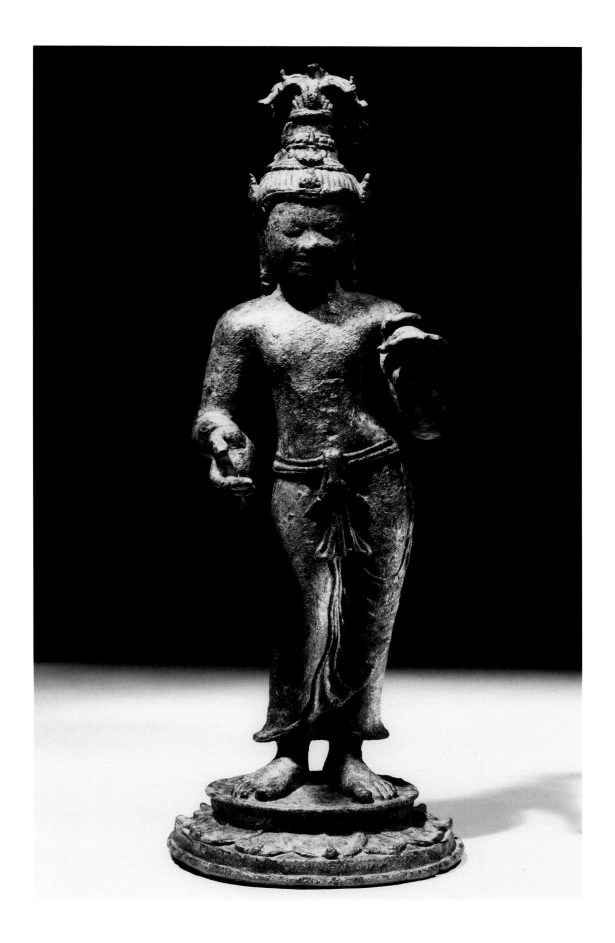

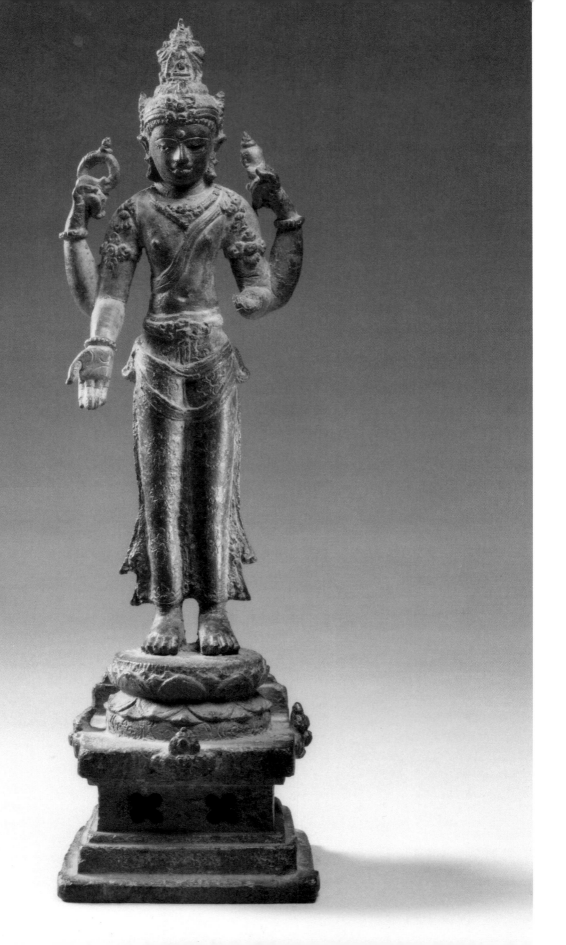

ASCETICISM AND EARLY ESOTERIC BUDDHISM

Multi-armed bodhisattvas and bodhisattva-ascetics are popular in the imagery of the western caves and in related material dating to the period of the Gupta empire. Reflecting to some extent the spread of esoteric Buddhism, both types of bodhisattvas are found in Southeast Asian Buddhist art from the seventh through the ninth centuries; an eight-armed figure of Avalokiteshvara in the collection of the Rijksmuseum in Amsterdam and a standing Maitreya in a private collection [47] are two examples. Moreover, the predominance of bodhisattva-ascetics (both at sites such as Prakhon Chai and throughout Southeast Asia) provides important information regarding the practice of Buddhism in Southeast Asia during this period and its relationship to some of the earliest Indian traditions of esoteric Buddhism.

As has already been mentioned, in early Indian art bodhisattvas were generally depicted as worldly princes wearing rich clothing and elaborate jewelry (see [38]). From the fourth through the ninth century, however, changes in the iconography of bodhisattvas indicate that the asceticism once associated primarily with Maitreya became essential to the imagery of other bodhisattvas, in particular Avalokiteshvara. The change from the elaborate clothing of earlier bodhisattvas to the simpler garments common in later images, the hair depicted as long and matted [46], and the use of animal hides as outer wrappings [42] are among the most noticeable attributes defining certain images of bodhisattvas as ascetics.

A sculpture of Maitreya attributed to Prakhon Chai now in the collection of the Kimbell Art Museum [1], a four-armed Avalokiteshvara from Sri Lanka in The Asia Society's Mr. and Mrs. John D. Rockefeller 3rd Collection [27], and a four-armed Avalokiteshvara from Sumatra in a private collection [26] illustrate the variety of bodhisattva-ascetics found in early Southeast Asian Buddhist art. All three bodhisattvas have long, tangled locks. Unlike the images from Prakhon Chai and Sri Lanka, the bodhisattva from Sumatra wears jewelry. Both the Sri Lankan and Sumatran examples wear the skins of animals: the Sri Lankan Avalokiteshvara has a tiger skin wrapped around his hips, while the figure from Sumatra wears a tiger skin in

48

AVALOKITESHVARA

Indonesia, Java; Central Javanese period, 9th century

Bronze

8 in (20.3 cm)

Private collection

the same fashion and has an antelope skin over his shoulders.[31]

Symbolic of a lack of worldly goods or attachments, the wearing of animal skins has a long history of religious significance in India; the use of the antelope skin as an initiation garment for both sacrifices and coronations can be traced to early Indian history.[32] The use of animal skins in the representations of bodhisattvas illustrates both the growing importance of ascetics to Indian religious thought from the fourth through the seventh centuries and the contributions of these adepts to the development of esoteric Buddhism.

The distinction between monks who live in cities (or at major monasteries) and practice their vocation through the study of texts and those who spend their time in solitary meditation in the forest is well established in Buddhism, and both paths have always remained available to practitioners. While the evolution of esoteric Buddhism remains very difficult to chart, it is generally agreed that the impetus for the solitary path came from practices shared by thaumaturges and other adepts, some of whom were affiliated with Buddhism and some of whom were not, whose pursuit of self-perfection and enlightenment was solitary and whose teachings were transmitted orally rather than recorded in texts.

The prevalence of bodhisattva-ascetics in the visual arts of India and Southeast Asia from the seventh through the ninth centuries[33] illustrates the importance of asceticism in the development and spread of early esoteric Buddhism during this period. In addition to the numerous images of Avalokiteshvara and Maitreya as ascetic bodhisattvas, two small sculptures of seated ascetics have also been attributed to Prakhon Chai.[34] The seated Buddha in the headdress of a figure in The Brooklyn Museum of Art (see [49]) illustrates his Buddhist affiliation, while the scanty clothing, matted hair, and long beard indicate that this personage followed a solitary religious path; it has been suggested that this figure represents a local monk who was apotheosized and worshiped, a custom that appears to have been prevalent in Cambodia.[35]

The depiction of similar figures at sites in Thailand, Cambodia, and Burma, on the other hand, suggests that the

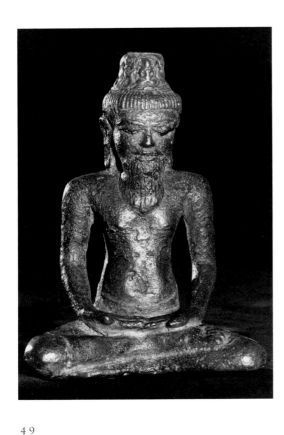

49

ASCETIC

Thailand, excavated at Prakhon Chai; 8th century

Bronze

5 in (12.7 cm)

The Brooklyn Museum of Art, Museum Purchase with Funds from Charles Bloom Foundation

Prakhon Chai ascetic images, whether or not they are portraits of actual monks, represent yet another aspect of the interest in asceticism that appears to have played an important role in the transmission of esoteric Buddhism to Southeast Asia. Ascetic figures are represented on a seventh-century Dvaravati relief of the Buddha's first sermon;[36] on a lintel from the Prasat Thna Dap, a ninth-century temple in Cambodia;[37] and in the Abeyadana temple, a late-eleventh-century Burmese site believed to have had some tantric affiliation.[38] Moreover, recent scholarship on the current practice of Buddhism in various parts of mainland Southeast Asia provides tantalizing glimpses into the persistence of ascetic and tantric practices that may help explain the importance of ascetic figures and bodhisattva-ascetics, further underlining the importance of visual traditions in the study of the history of religion.

One example of such survivals is the Ari sect in Burma.[39] Most of the information regarding this sect is couched in negative terms, as its practices, which differ noticeably from those of the orthodox Theravadins (the predominant sect in Burma), are said to have been proscribed by King Aniruddha in the eleventh century. In addition, the exact dates for the flowering of this sect are not known, although it appears to have been most important from the seventh through the thirteenth century. Nonetheless, it is generally accepted that the Aris were solitary monks, noted for their austerities, magical feats, and incantations, practices that can be linked to the rise of esoteric Buddhism. Records of wandering masters with similar magical skills are also found in the annals of the Chinese kingdom of Nanzhao (mid-seventh to the beginning of the tenth century).[40] Located in Yunnan Province in southwest China, Nanzhao had strong ties to both China and the nations of mainland Southeast Asia, and the Buddhist practices and art of Yunnan are closely tied to those of its Southeast Asian neighbors.

An analysis of traditional texts and of contemporary practices, such as initiation rites in Cambodia, also reveals vestiges of earlier religious activities that reflect the importance of ascetics in the development and spread of some of the earliest forms of esoteric Buddhism.[41] These include meditation techniques that differ noticeably from those found in contemporary Theravada Buddhism; a stress on the use of psychophysical disciplines, such as incantations, as a means to immediate enlightenment; the importance of a teacher-disciple relationship in the transmission of certain techniques; and the belief that a highly esteemed teacher need not necessarily have been trained in monastic scholarship in order to pursue enlightenment or help others in their own pursuit.

Preserved in contemporary Buddhist literature, in sculptures dating from the seventh through the ninth centuries, and in the practices of masters such as the Aris,

50

MONK

China, Shaanxi, Yungang, cave 7; late 5th century
After Mizuno and Nagahiro 1952, pl. 26

ascetic and psychomagical disciplines appear to have played an important role in early Southeast Asian Buddhism. These physical and mental exercises fell into disuse after the adoption of the Mahavaharasin sect of Theravada Buddhism imported into Southeast Asia from the eleventh through the thirteenth century, and a full understanding of the importance of these types of activities and their relationship to early tantric traditions in Southeast Asia remains elusive. Nonetheless, the numerous representations of great bodhisattvas such as Maitreya and Avalokiteshvara as ascetics found at Prakhon Chai and other sites throughout Southeast Asia provide primary evidence for the importance of asceticism (and possibly of some of the early tantric practices) to the development of Buddhism there from the seventh through the ninth century.

MAITREYA AND ESOTERIC BUDDHISM
The importance awarded to the Bodhisattva Maitreya at Prakhon Chai and related pre-Angkor sites, on the other hand, continues to distinguish the iconography of this material from that of other art traditions of early Southeast Asian Buddhism. The monumental figure of Maitreya carved on the walls of the famous Thamorat cave near Si Thep is one of the rare examples of images of this bodhisattva not attributed to the area around Prakhon Chai.[42] Additional examples from Thailand include an image on a gold plaque attributed to the kingdom of Dvaravati[43] and a bronze sculpture excavated at Ban Lan Khwai in Pattani Province [24]. Finally, an example of Maitreya as a bodhisattva-ascetic was excavated in Sri Lanka in 1983.[44]

The importance of the *Gandavyuha* in Javanese Buddhism suggests one possible explanation for the prominence awarded to Maitreya at Prakhon Chai.[45] Probably compiled about 400 C.E., the *Gandavyuha* is part of an important Buddhist text known as the *Avatamsaka sutra*. Influential in India, Java, and China, the *Avatamsaka sutra* played an important role in the transmission of esoteric Buddhism to East Asia. Filled with magical feats and mystical moments, the *Gandavyuha*, which narrates the pilgrimage of a young boy named Sudhana as he travels from teacher to

teacher in search of enlightenment, was particularly popular in Java: over one-third of the narrative reliefs on the Borobudur illustrate scenes from Sudhana's pilgrimage.[46] Maitreya is one of the teachers whom Sudhana visits, and he plays a crucial role in helping the young pilgrim understand the nature of enlightenment. In addition, the *Gandavyuha* describes Maitreya as a master of meditation techniques and trances,[47] thereby linking Maitreya to the interest in these practices found in early Southeast Asian Buddhism. However, with the exception of the art from the Prakhon Chai area, images of Maitreya were relatively scarce in Southeast Asian Buddhist art, and the importance awarded to Maitreya as a master of meditation techniques is not illustrated in the Maitreya scenes found on the Borobudur. If the Borobudur is based on the *Gandavyuha*, then it seems that the worship of Maitreya as an adept in meditation may reflect a distinctive regional interpretation of the pertinent passages in that text, or it is possible that the interest in Maitreya in the Prakhon Chai area is based on another text, and/or illustrates a separate development in the transmission of Buddhism to Southeast Asia.

A fascinating parallel for the association of Maitreya imagery with that of ascetics and forest monks is found in the visual arts of Central Asia and China. Images of meditating monks are found in the third- to seventh-century Central Asian site of Kizil[48] as well as in the fifth- and sixth-century Chinese cave temples at Dunhuang and Yungang [50], both of which are located in Shaanxi Province. As has already been mentioned, images of Maitreya played an important role at these sites, reflecting the importance accorded the veneration of Maitreya in this part of the world. Several sutras, including the Sanskrit *Buddhanusmrtisamadhisagara sutra* attributed to the fifth-century monk Buddhabhadra and the extant Chinese-language recensions of the *Chanbiyaofaching* and the *Siweimoyafayaoching*,[49] both of which are believed to have been written by Kumarajiva in the fourth century, include references to the belief that meditation will lead to rebirth in Maitreya's Tushita Heaven, and it is possible that many of the meditating monks seen at Kizil, Dunhuang, and Yungang can be understood as visual references to this belief.

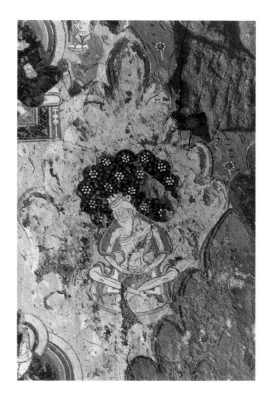

51

ASCETIC

China, Xinjiang, Kizil, cave 58; 5th-6th centuries
After Chugoku Sekkutsu: Kijiru Sekkutsu,
vol. 1, pl. 138.

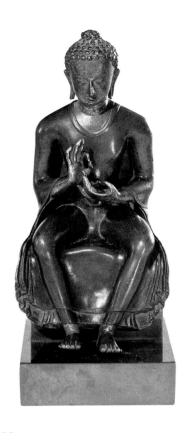

5 2

BUDDHA MAITREYA

Nepal; 12th century

Bronze

9 in (23.0 cm)

The Asia Society, The Mr. and Mrs. John D.
Rockefeller 3rd Collection

opposite

5 3

BODHISATTVA

Cambodia; 7th century

Bronze

11 ¼ in (28.5 cm)

Doris Wiener collection

In addition to meditating monks, images of ascetics (see [51]) also play an important role in the art of Kizil.[50] Paintings of scantily clad, emaciated figures with long, matted hair meditating in the mountains and forests, or occasionally offering gifts to preaching Buddhas, are common here. Much more work needs to be done on the iconography of Kizil and its contributions to Buddhist art. Nonetheless, the prevalence of ascetic imagery suggests a link between ascetic disciplines and the worship of the Bodhisattva Maitreya; and this association is also found in the art of Buriram Province in Thailand as exemplified at the site of Prakhon Chai.

The development of the cult of Maitreya on the northwest Indian frontier (including Pakistan, Kashmir, and parts of Central Asia) and the preponderance of images of Maitreya in the visual arts of Kashmir and Nepal from the sixth through the eleventh centuries suggests that worship of this deity remained very popular in this region of Asia. Moreover, this area has been linked to the development of esoteric Buddhism; found in the writings of the Lokottaravadin branch of the Mahasamghikas, the emphasis on the Buddha as a supramundane being (*lokottara*) of unlimited power and longevity contributed to the redefinition of the path to Buddhahood that led ultimately to the evolution of the esoteric tradition of Buddhism.[51] As previously mentioned, the *Mahavastu* and other texts associated with the Mahasamghikas played an important role in the development of the worship of Maitreya. Moreover, certain images and practices that were prevalent in this area from the fourth through the twelfth centuries contributed significantly to the development of esoteric Buddhist imagery during this period.[52]

The biography of the monk Punyodaya provides a possible route for the transmission of northwest Indian and Central Asian Buddhist traditions, including links between the worship of Maitreya, asceticism, and esoteric Buddhism, to Cambodia and neighboring north central Thailand. Born in central India, Punyodaya studied Buddhism in both Sri Lanka and the Gandhara region before reaching Changan (present day Xi'an), the capital of Tang Dynasty China, in 655 C.E.[53] Due possibly to

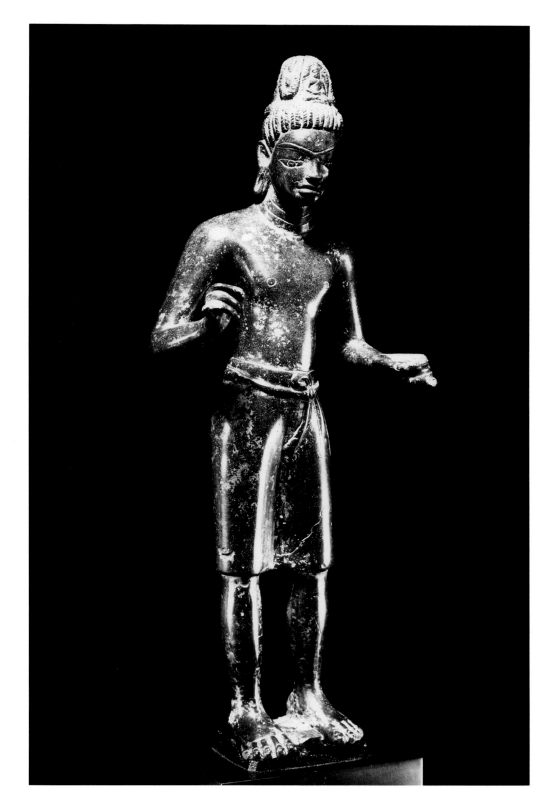

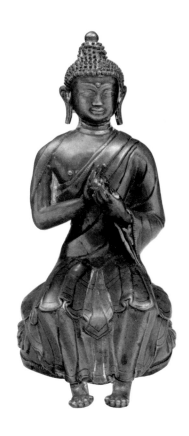

54

BUDDHA MAITREYA

Tibet; 13th century

Gilt bronze

6 ¾ in (17.1 cm)

Zimmerman Family collection

political intrigue among rival Buddhist factions, a year after his arrival Punyodaya, who had at first been well received, was sent to Cambodia to gather medicinal herbs. He returned to China in 663 and was apparently sent back to Cambodia in 664. Punyodaya is believed to have reached China with over five hundred manuscripts, and to be one of the first monks to introduce esoteric Buddhism to the Chinese court. Only three texts remain associated with his name. One is a recension of the *Dashabhumika sutra*, which lists the ten birth stages of a bodhisattva; the second is a version of the *Ashtamandalaka sutra*, which introduces the mandala of the eight bodhisattvas, an image that was particularly important in Central Asian, Southeast Asian, and early Nepali and Tibetan Buddhism;[54] and the third is a recension of the *Atanitiya*, a text conserved in both a Pali and a Tibetan version.[55]

Punyodaya's studies in the northwest part of the Indian frontier, and his interest in esoteric Buddhism, suggest a provenance for the existence of an early aspect of esoteric Buddhism in which Maitreya (who is not prominent in Tibetan Buddhism) plays an important role in the meditative practices of monks and adepts. As has already been mentioned, Maitreya's position as a master of meditation is explained in several Buddhist sutras and can probably be linked to the asceticism that was integral to the development of the cult of Maitreya. In addition, the important role played by adepts, some Buddhist and some not, in the evolution of esoteric Buddhism is generally acknowledged. Finally, Punyodaya's interest in the ten birth stages links his work to the pre-Mahayana traditions of the Mahasamghikas and, in this respect, it is interesting that the vestiges of tantric practices found in Southeast Asia today are allied to Theravada Buddhism and not the later Mahayana tradition.[56]

CONCLUSION

The sculpture discovered at Prakhon Chai raises several interesting questions regarding the development of regional styles of Buddhist art in mainland Southeast Asia, and the study of this material has focused on the analysis of such issues. However, Prakhon Chai is also significant from the point of view of

Buddhist iconography. The importance of bodhisattva-ascetics in the art of this site relates the material to comparable works found throughout Southeast Asia, adding to our understanding of the development of Buddhist thought both in Southeast Asia and in India; the prominence awarded to the Bodhisattva Maitreya in the art of Prakhon Chai adds a new dimension to this evolution, suggesting links between the art of this part of Southeast Asia and the Buddhist cultures of India's northwest frontier, Central Asia, and Northwest China. Finally, and perhaps most notably, the sculptures found at Prakhon Chai attest to the importance of the study of the visual arts for the understanding of the history of religion. The iconography of sculptures such as the images of Maitreya from Prakhon Chai provide information for the study of the evolution of Buddhist thought and practices. Combined with the evidence of texts and the persistence of esoteric disciplines found in such sects as the Aris in Burma, the art of Southeast Asia helps refine the many ways in which beliefs and practices united the Buddhist world and ultimately led to the development and spread of esoteric Buddhism from the seventh through the ninth centuries.

NOTES

1. For a good overview (with illustrations) of the discovery of sculptures at Prakhon Chai see Bunker 1971-72, 67-76. For the related material from Ban Fai see *New Acquisitions of Three Bronzes from Buriram* 1973. For an important review of the latter see Woodward 1974, 317-75.

2. Possibly due to his joint status as a Buddha and a bodhisattva, Maitreya is accepted as the only bodhisattva who is worshiped in Theravada Buddhism.

3. For an overview of this issue see Rosenfield 1967, 227-44.

4. For a discussion of the role played by Buddhist imagery in imperial coinage see Cribb 1980, 79-87.

5. Miyaji 1992, PLS. 24, 46, FIGS. 118, 129, 166.

6. For the *Mahavastu* discussion of Maitreya see Jain 1988, 54-90. For the importance of the Mahasamghikas see Klimburg-Salter 1989.

7. Encho 1985.

8. Thomas 1935-63, 75, 305, 306.

9. Emmerick 1968.

10. In this part of the world, Maitreya is generally identified through iconographic context or by means of his distinctive posture: he is either shown cross-legged or with one leg resting on the other. For illustrations see Encho 1985. For a slightly different interpretation of the spread of this imagery see Leidy 1990, 21-37.

11. Bhattacharya 1980, 100-111. For the precise citation from Xuan Zang see Beal 1884, 142-44.

12. Bhattacharya 1980, 103.

13. See Miyaji 1992, FIGS. 214, 215, 216, 218; Snellgrove 1978, PL. 69.

14. Hallade 1968, FIG. 138; *Marg* 1967, 26 (NO. 25).

15. Miyaji 1992, FIGS. 212, 213; *Marg* 1967, FIG. 5.

16. *Marg* 1967, FIG. 20.

17. For an overview of this issue see Wayman 1973.

18. De Mallmann 1948, 308-11. Prior to this period, Avalokiteshvara was often identified by his turban or by the lotus that he holds in his hands.

19. De Mallmann 1948, 308.

20. De Mallmann 1948, 308.

21. Diskul 1980c, 3.

22. Diskul 1980c, 3.

23. Wolters 1961, 417-18.

24. Wolters 1961, 418.

25. Lerner 1991, 162.

26. The literature on this monument is voluminous. For a good overview and illustrations see Bernet Kempers 1976.

27. For illustration see Pal 1984, PLS. 29-34.

28. Huntington 1981, 46-55.

29. Wayman 1981, 139-65.

30. Huntington 1981, 47-48.

31. It has been suggested that the bodhisattvas from Prakhon Chai may once have held movable attributes that were lost. It is not impossible that they were also dressed with actual hides, although there is no known precedent for such a practice.

32. De Mallmann 1948, 219-20.

33. The disappearance of bodhisattva-ascetics in Buddhist art after the ninth century requires further study. It may be associated with the rise of the cult of the mahasiddhas and the importance of these figures in Buddhist art dating from the eleventh century on.

34. Bunker 1971-72, FIG. 27, and [49].

35. Pal 1978, 129.

36. Dupont 1959, PL. 509.

37. Boisselier 1966, PL. XXXIII.

38. Luce 1969-70, PLS. 213-35.

39. Strong 1992, 70, 176-78, 244, 279. For a slightly different interpretation see Chutiwongs 1984, 100-101.

40. Howard 1990, 9.

41. Bizot 1988; Bizot 1989, 14-17.

42. Quaritch Wales 1969, 50-51.

43. Pal 1986, 36, FIG. 20.

44. *Bronzes bouddhiques* 1992, 89, NO. 20.

45. Fontein 1966.

46. For a discussion of the Borobudur as Maitreya tower (*kutagara*) see Gomez 1981, 173-94.

47. Jain 1988, 69.

48. For a different dating of Kizil see Falcon 1991.

49. Miyaji 1992, 411-524. For an earlier discussion of this material see Miyaji 1989, 29-60. For the related material from Dunhuang see Hirotoshi 1989, 11-28.

50. Images of monks and ascetics meditating in front of skeletons appear at Kizil (Miyaji 1992, FIGS. 256, 259). Such imagery plays a fairly important role in Tibetan Buddhist art, which suggests that the imagery at this site may provide intriguing prototypes for the better-known imagery of esoteric Tibetan Buddhism.

51. Klimburg-Salter 1989, 58.

52. Klimburg-Salter 1989, 93FF.

53. Kouang 1935, 83-100.

54. For a discussion of Indian and Southeast Asian imagery related to this sutra see Woodward 1988.

55. Kouang 1935, 91FF.

56. Bizot 1989, 14-16.

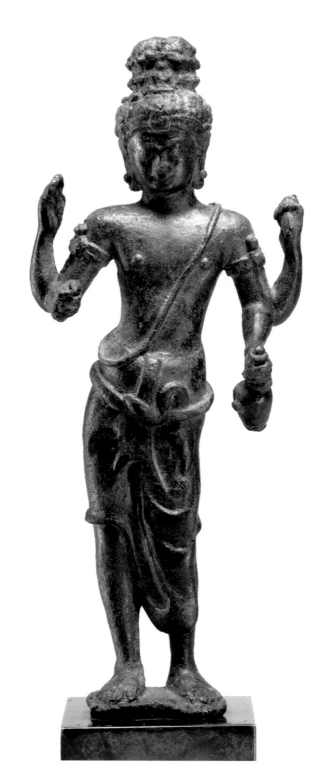

55

BODHISATTVA

Thailand; late 8th century
Bronze
6 in (15.2 cm)
Private collection

BIBLIOGRAPHY

Ancient Inscriptions from Lop Buri and Its Vicinity (in Thai). Bangkok: Fine Arts Department, 1981.

AUNG THAW

1968 *Report on the Excavations at Beikthano.* Rangoon: Ministry of Union Culture.

1972 *Historical Sites in Burma.* Rangoon: Ministry of Union Culture.

BANDARANAYAKE, S., L. DEWARAJA, R. SILVA, AND K.D.G. WIMALARATNE, EDS.

1990 *Sri Lanka and the Silk Road of the Sea.* Colombo: Sri Lanka National Commission for UNESCO and the Central Cultural Fund.

BARRETT, D.

1954 The Later School of Amaravati and Its Influences. *Art and Letters* 28(2):41-53.

BAREAU, A.

 Les sectes bouddhiques du petit vehicule. Paris.

BAUER, C.

1991 Notes on Mon Epigraphy. *Journal of the Siam Society* 79(1):31-83.

BEAL, S.

1884 *Buddhist Records of the Western World.* Reprint, VOL. 2, 1969.

BÉNISTI, M.

1970 *Rapports entre le premier art khmer et l'art indien.* Paris: École Française d'Extrême-Orient.

BERNET KEMPERS, A. J.

1959 *Ancient Indonesian Art.* Amsterdam: Van der Peet.

1976 *Ageless Borobudur: Buddhist Mystery in Stone, Decay and Restoration.* Wassenaar, The Netherlands: Servire.

BHATTACHARYA, G.

1980 The Stupa as Maitreya's Emblem. In *The Stupa: Its Religious, Historical and Architectural Significance.* Wiesbaden: Franz Steiner Verlag, 100-111.

BIZOT, F.

1988 *Les Traditions de la pabbajja en Asie du Sud-Est.* Recherches sur le bouddhisme khmer, VOL. 4. Paris: École Française d'Extrême-Orient.

1989 *Ramaker à L'Amour Symbolique de Ram et Seta.* Recherches sur le bouddhisme khmer, VOL. 5. Paris: École Française d'Extrême-Orient.

BOISSELIER, J.

1955 *La statuaire khmere et son évolution.* 2 VOLS. Paris: École Française d'Extrême-Orient.

1963 *La statuaire du Champa: Recherches sur les cultes et l'iconographie.* Paris: École Française d'Extrême-Orient.

1966 *Le Cambodge.* Paris: A. et J. Picard et Cie.

1967 Notes sur l'art du bronze dans l'ancien Cambodge. *Artibus Asiae* 29:275-334.

1968a *Le Cambodge.* Manuel d'archéologie d'Extrême-Orient, PT. 1, VOL. 1. Paris: Éditions A. et J. Picard et Cie.

1968b *Nouvelles connaissances archéologiques de la ville d'U-Thong.* Bangkok: Fine Arts Department.

1969 Recherches archéologiques en Thaïlande 2. *Arts Asiatiques* 20:47-111.

1972 Travaux de la mission archéologique française en Thaïlande. *Arts Asiatiques* 25 (July-November 1966): 27-90.

BOISSELIER, J., AND J. M. BEURDELEY

1974 *La sculpture en Thaïlande.* Fribourg, Switzerland: Office du Livre.

LE BONHEUR, A.

1972 Un bronze d'époque préangkorienne representant Maitreya. *Arts Asiatiques* 25:129-54.

BOWIE, T., S. DISKUL, AND A. B. GRISWOLD

1972 *The Sculpture of Thailand.* New York: The Asia Society.

BRONSON, B.

1979 The Late Prehistory and Early History of Central Thailand with Special Reference to Chansen. In *Early South East Asia,* edited by R. B. Smith and W. Watson. London: Oxford University Press, 315-36.

1986 Glass and Beads at Khuan Lukpad, Southern Thailand. In *Southeast Asian Archaeology 1986, Proceedings of the First Conference of the Association of Southeast Asian Archaeologists in Western Europe.* London: Institute of Archaeology, University of London, 213-31.

Bronzes Bouddhiques et Hindous de l'antique Ceylan: Chefs-d'oeuvre des musées du Sri Lanka. Paris: Association Française d'Action Artistique, 1991.

BUNKER, E. C.

1971-72 Pre-Angkor Period Bronzes from Pra Kon Chai. *Archives of Asian Art* 25:67-76.

CRIBB, J.

1980 Kanishka's Buddhist Coins—The Official Iconography of Shakyamuni and Maitreya. *Journal of the International Association of Buddhist Studies* 3(1):79-87.

DE CASPARIS, J. G.

1975 *Indonesian Palaeography.* Handbuch der Orientalistik. Leiden/Cologne: E. J. Brill.

CHAROENWONGSA, P., AND S. DISKUL

1976 *Thailande.* Archaeologia Mundi. Geneva: Édition Nagel.

CHHABRA, B. C.

1965 *Expansion of Indo-Aryan Culture During Pallava Rule (As Evidenced by Inscriptions).* Delhi: Munshi Ram Manohar Lal.

Chugoku Sekkutsu: Kijiru Sekkutsu. Tokyo: Heibonsha, 1983–85

CHUTIWONGS, N.

1984 *The Iconography of Avalokiteśvara in Mainland South-East Asia.* Ph.D. diss. Leiden: University of Leiden.

1986 Sri Lanka and Some Bodhisattva Images from Southeast Asia. In *Studies in South and Southeast Asian Archaeology: Essays Offered to Dr. J. G. de Casparis.* Leiden: University of Leiden, 68-82.

1990 *Indonesian Bronzes in the Domela Nieuwenhuis Collection.* Amsterdam: Christie's Amsterdam.

COEDÈS, G.

1937–66 *Inscriptions de Cambodge.* 8 vols. Hanoi and Paris: École Française d'Extrême-Orient.

1968 *The Indianized States of Southeast Asia.* Honolulu: East-West Center Press.

DE CORAL RÉMUSAT, G.

1951 *L'art khmer: Les grandes étapes de son évolution.* Paris: Vanoest Éditions d'Art et d'Histoire.

DE MALLMANN, M.-T.

1948 *Introduction a l'étude d'Avalokitecvara.* Annales du Musée Guimet, VOL. 57. Paris.

DISKUL, S.

1979A *Art in Thailand: A Brief History.* Rev. ed. Bangkok: Amarin Press.

1979B The Development of Dvaravati Sculpture and a Recent Find from Northeast Thailand. In *Early South East Asia,* edited by R. B. Smith and W. Watson. London: Oxford University Press, 360-70.

1980A Chedi at Wat Keo, Chaiya, Suratthani. *Journal of the Malaysian Branch of the Royal Asiatic Society* 53 (PT. 2): 1-4.

1980B Śrīvijaya Art in Thailand. In *The Art of Śrīvijaya,* edited by S. Diskul. Kuala Lumpur: UNESCO, 21-43.

DISKUL, S., ED.

1980C *The Art of Śrīvijaya.* London: Oxford University Press.

DUPONT, P.

1955 *La statuaire préangkorienne.* Artibus Asiae Supplementum, NO. 15. Ascona, Switzerland: Artibus Asiae Publishers.

1959 *L'archéologie mône de Dvāravatī.* 2 vols. Paris: École Française d'Extrême-Orient.

DUROISELLE, C.

1926-27 Excavations at Hmawza. *Archaeological Survey of India, Annual Report,* 171-83.

1927-28 Excavations at Hmawza. *Archaeological Survey of India, Annual Report,* 127-35.

1936-37 Exploration in Burma. *Archaeological Survey of India, Annual Report,* 74-84.

EMMERICK, R. E.

1968 *The Book of Zambasta.* New York: Oxford University Press.

ENCHO, T.

1985 *Hanka Shiizo no Kenkyu* (A Study of Figures in the Pensive Pose). Tokyo: Yoshikawa Kobunkan.

FALCON, A. H.

1991 In Support of a New Chronology for the Kizil Mural Paintings. *Archives of Asian Art* 44:68-83.

FELTEN, W., AND M. LERNER

1989 *Thai and Cambodian Sculpture from the 6th to the 14th Centuries.* London: Philip Wilson.

FONTEIN, J.

1966 *The Pilgrimage of Sudhana.* The Hague and Paris: Mouton.

FONTEIN, J., ED.

1990 *The Sculpture of Indonesia.* Washington, D.C.: National Gallery of Art.

FONTEIN, J., R. SOEKMONO, AND S. SULEIMAN

1971 *Ancient Indonesian Art of the Central and Eastern Javanese Periods*. New York: The Asia Society.

FRÉDÉRIC, L.

1964 *Sud-Est Asiatique: Ses temples, ses sculptures*. Paris.

GLOVER, I. C.

1989 *Early Trade between India and South East Asia: A Link in the Development of a World Trading System*. Hull, England: Centre for South East Asian Studies, University of Hull, Occasional Papers (NO. 16).

GOMEZ, L. O.

1981 Observations on the Role of the Gandavyuha in the Design of the Barabudur. In *Barabudur: History and Significance of a Buddhist Monument*, edited by L. Gomez and H. Woodward. Berkeley: Berkeley Buddhist Studies, 173-94.

GRISWOLD, A. B.

1960 *The Arts of Thailand: A Handbook of the Architecture, Sculpture, and Painting of Thailand (Siam), and a Catalogue of the Exhibition in the United States 1960-62*. Bloomington, Indiana: Indiana University Press.

1966 Imported Images and the Nature of Copying in the Art of Siam. In *Essays offered to G. H. Luce*, VOL. 2. Ascona, Switzerland: Artibus Asiae Publishers, 37-73.

GROSLIER, B. P.

1962 *The Art of Indochina*. Art of the World series. London: Methuen.

GUTMAN, P.

1978 Ancient Coinage of Southeast Asia. *Journal of the Siam Society* 66 (PT. 1): 8-21.

HALLADE, M.

1968 *Indien: Gandhara: Begegnung zwischen Orient und Okzident*. Fribourg, Switzerland.

HIGHAM, C.

1989 *The Archaeology of Mainland Southeast Asia: From 10,000 B.C. to the Fall of Angkor*. Cambridge World Archaeology. Cambridge, England: Cambridge University Press.

HIROTOSHI, S.

1989 Zenjo biku zuzo to tonko dai nihyakuhatizyugo kutsu (Paintings of Buddhist Priests in Meditative Concentration and the 258th Cave of Dunhuang). *Ars Buddhica* 183:11-28.

HOWARD, A. F.

1990 A Gilt Bronze Guanyin from the Nanzhao Kingdom of Yunnan: Hybrid Art from the Southwestern Frontier. *Journal of the Walters Art Gallery* 48:9.

HUNTINGTON, J.

1981 Cave Six at Aurangabad: A Tantrayana Monument? In *Kaladarsana: American Studies in the Art of India*, edited by Joanna G. Williams. Leiden: E.J. Brill.

Inscriptions from Si Thep. In Thai. Bangkok: Fine Arts Department, 1991.

JACQUES, C.

1979 "Funan," "Zhenla," The Reality Concealed by the Chinese Views of Indochina. In *Early South East Asia*, edited by R. B. Smith and W. Watson. London: Oxford University Press, 371-79.

1986 Sources on Economic Activities in Khmer and Cham Lands. In *Southeast Asia in the 9th to 14th Centuries*, edited by D. G. Marr and A. C. Milner. Singapore: Institute of Southeast Asian Studies, Singapore and the Research School of Pacific Studies, Australian National University, 327-34.

JAIN, PADMANABHA S.

1988 Stages in the Bodhisattva Career of Tathagata Maitreya. In *Maitreya, The Future Buddha*, edited by Alan Sponbery and Helen Hardacre. London and New York: Cambridge University Press.

KHWANYUN, S.

1980 Excavations of Ancient Monuments at Nadun District, Mahasarakham. In Thai. *Silpakon* 24(2):71-84.

KLIMBURG-SALTER, D.

1989 *The Kingdom of Bamiyan: Buddhist Art and Culture of the Hindu Kush*. Naples and Rome: Instituto Universitario Orientali.

KOUANG, L.

1935 Punyodaya — un propagateur du Tantrisme en Chine et au Cambodge a l'époque de hiuan-tsang. *Journal Asiatique* 226:83-100.

KRAIRIKSH, P.

1974 Semas with Scenes from the Mahanipata-Jatakas in the National Museum at Khon Kaen. In *Art and Archaeology in Thailand*, VOL. 1. Publication in Commemoration of the 100th Anniversary of the National Museum. Bangkok: Fine Arts Department.

1979 *The Sacred Image: Sculptures from Thailand.* Cologne: Museum für Ostasiatische Kunst der Stadt Köln.

1980 *Art in Peninsular Thailand prior to the Fourteenth Century.* Bangkok: Fine Arts Department.

KULKE, H.

1986 The Early and Imperial Kingdom in Southeast Asian History. In *Southeast Asia in the 9th to 14th Centuries*, edited by D. G. Marr and A. C. Milner. Singapore: Institute of Southeast Asian Studies, Singapore and the Research School of Pacific Studies, Australian National University, 1-22.

LEIDY, D. P.

1990 The Ssu-wei Figure in Sixth-Century A.D. Chinese Buddhist Sculpture. *Archives of Asian Art* 43:21-37.

LERNER, M.

1985 *The Flame and the Lotus: Indian and Southeast Asian Art from the Kronos Collections.* New York: The Metropolitan Museum of Art and Harry N. Abrams.

1991 *The Lotus Transcendent.* New York: The Metropolitan Museum of Art.

LOOFS, H.H.E.

1979 Problems of Continuity between the Pre-Buddhist and Buddhist Periods in Central Thailand, with Special Reference to U Thong. In *Early South East Asia*, edited by R. B. Smith and W. Watson. London: Oxford University Press, 342-51.

LOWRY, J.

1974 *Burmese Art.* London: Victoria and Albert Museum.

LUCE, G. H.

1969-70 *Old Burma—Early Pagan.* 3 vols. Locust Valley, N.Y.: J.J. Augustin Publisher.

LUNSINGH SCHEURLEER, P., AND M. KLOKKE

1988 *Divine Bronze: Ancient Indonesian Bronzes from A.D. 600 to 1600.* Amsterdam: Museum of Asiatic Art, Rijksmuseum.

LYONS, E.

1979 Dvaravati, A Consideration of Its Formative Period. In *Early South East Asia*, edited by R. B. Smith and W. Watson. London: Oxford University Press, 352-59.

MABBETT, I.

1986 Buddhism in Champa. In *Southeast Asia in the 9th to 14th Centuries*, edited by D. G. Marr and A. C. Milner. Singapore: Institute of Southeast Asian Studies, Singapore and the Research School of Pacific Studies, Australian National University, 289-314.

Marg 20(2):26 (NO. 5) and FIG. 20 (March 1967).

MASPERO, G.

1928 *Le Royaume de Champa.* Paris and Brussels.

Masterpieces of Bronze Sculpture from Ban Fai, Lam Plai Mat, Buri Ram. Bangkok: Fine Arts Department, 1973.

MITCHINER, M.

1982 The Date of Early Funanese, Mon, Pyu, and Arakanese Coinage ("Symbolic Coins"). *Journal of the Siam Society* 70 (PTS. 1-2): 5-12.

MIYAJI, A.

1989 Zenjoso, sangaku kosei, Miroku no zuzu kosei (Iconographical Composition of Priests in Meditation, Mountains, and Maitreya). *Ars Buddhica* 183:11-28.

1992 *Nehan to Miroku no Zuzogaku: Indo kara Chou Ajia e* (Iconology of the Parinirvana and Maitreya). Tokyo: Yoshikawa Kobunkan.

MIZUNO, S., AND T. NAGAHIRO

1952 *Unko Sekkutsu (Yungang: The Buddhist Cave-Temples of the Fifth Century A.D. in North China)*, VOL. 7. Kyoto: Kyoto University.

MYA, U.

1961 *Votive Tablets of Burma.* In Burmese. 2 parts. Rangoon: Ministry of Union Culture.

NAI PAN HLA

1991 The Major Role of the Mons in Southeast Asia. *Journal of the Siam Society* 79 (PT. 1): 13-19.

New Acquisitions of Three Bronzes from Buriram. Bangkok: Fine Arts Department, 1973.

O'CONNOR, S. J.

1972 *Hindu Gods of Peninsular Siam.* Artibus Asiae Supplementum, NO. 28. Ascona, Switzerland: Artibus Asiae Publishers.

PACHOW, W.

1958 The Voyage of Buddhist Missions to South-East
 Asia and the Far East. *Journal of the Greater India Society*
 17(1 and 2):1-22.

PAL, P.

1978 *The Sensuous Immortals.* Los Angeles: The Los Angeles
 County Museum of Art.

1984 *Tibetan Paintings.* London and New York: Philip
 Wilson Publishers Ltd. and Sotheby's.

1990 Arhats and Mahasiddhas in Himalayan Art. *Arts of Asia*
 1(20):66-78.

PAL, P., ED.

1986 *American Collectors of Asian Art.* Bombay: Marg
 Publications.

QUARITCH WALES, H. G.

1969 *Dvaravati: The Earliest Kingdom of Siam (6th to 11th Century).*
 London: Bernard Quaritch Ltd.

1976 *The Malay Peninsula in Hindu Times.* London: Bernard
 Quaritch Ltd.

RAWSON, P.

1967 *The Art of Southeast Asia.* London: Thames and Hudson.

RAY, N. R.

1936 *Sanskrit Buddhism in Burma.* Amsterdam: H. J. Paris.

ROSENFIELD, J.

1967 *The Dynastic Arts of the Kushans.* Berkeley and Los
 Angeles: University of California Press.

SARKAR, H. B.

1971 *Corpus of the Inscriptions of Java*, VOL. 1. Calcutta: K. L.
 Mukhopadhyay.

VON SCHROEDER, U.

1990 *Buddhist Sculptures of Sri Lanka.* Hong Kong: Visual
 Dharma Publications.

Silpakon. Journal of the Fine Arts Department, Bangkok,
 32 (NO. 6, January–February 2532 [1989]).

SMITH, R. B.

1979 Mainland South East Asia in the Seventh and Eighth
 Centuries. In *Early South East Asia,* edited by R. B.
 Smith and W. Watson. London: Oxford University
 Press, 443-56.

SOEKMONO, R.

1979 The Archaeology of Central Java before 800 A.D. In
 Early South East Asia, edited by R. B. Smith and W.
 Watson. London: Oxford University Press, 457-72.

SNELLGROVE, D. L., ED.

1978 *The Image of the Buddha.* London: UNESCO.

SOPER, A.

1949 Literary Evidence for Early Buddhist Art in China.
 Oriental Art 2(1):28-35.

1959 *Literary Evidence for Early Buddhist Art in China.* Artibus
 Asiae Supplementum, NO. 19. Ascona, Switzerland:
 Artibus Asiae Publishers.

SPAFA Final Report. Consultative Workshop on Archaeological
 and Environmental Studies on Srivijaya Indonesia,
 September 16-30, 1985.

STARGARDT, J.

1990 *The Ancient Pyu of Burma*, VOL. 1. Cambridge.

STRONG, J.

1992 *The Legend and Cult of Upagupta.* Princeton, N.J.:
 Princeton University Press.

SULEIMAN, S.

1981 *Sculptures of Ancient Sumatra.* Jakarta: Pusat Penelitian
 Arkeologi Nasional.

THOMAS, F. W.

1935-63 *Tibetan Literary Texts and Documents Concerning Chinese
 Turkestan*, VOL. 2. London: Luzac for the Royal
 Asiatic Society.

VALLIBHOTAMA, S.

1986 Political and Cultural Continuities at Dvaravati Sites.
 In *Southeast Asia in the 9th to 14th Centuries,* edited by D.
 G. Marr and A. C. Milner. Singapore: Institute of
 Southeast Asian Studies, Singapore and the
 Research School of Pacific Studies, Australian
 National University, 229–38.

VEERAPRASERT, M.

1985 Khlong Thom: An Ancient Bead-Manufacturing
 Location and an Ancient Entrepôt. In *Research
 Conference on Early Southeast Asia.* Bangkok: Silpakon
 University, 168-69.

VICKERY, M.

1986 Some Remarks on Early State Formation in
 Cambodia. In *Southeast Asia in the 9th to 14th Centuries*,
 edited by D. G. Marr and A. C. Milner. Singapore:
 Institute of Southeast Asian Studies, Singapore and
 the Research School of Pacific Studies, Australian
 National University, 95-115.

VIRIYABUS, C.

1974 Notes on the Statuettes Found at Khonburi, Korat. In
 Art and Archaeology in Thailand, VOL. 1. Publication in
 Commemoration of the 100th Anniversary of the
 National Museum. Bangkok: Fine Arts Department,
 195-200.

WANG GUNGWU

1958 The Nanhai Trade. *Journal of the Malaysian Branch of the
 Royal Asiatic Society* 31 (PT. 2): 1-135.

WAYMAN, A.

1973 *The Buddhist Tantras.* London: Routledge and Kegan
 Paul Ltd.

1981 Reflections on the Theory of Barabudur as a
 Mandala. In *Barabudur: History and Significance of a
 Buddhist Monument*, edited by L. Gomez and H.
 Woodward. Berkeley: Berkeley Buddhist Studies.

WHEATLEY, P.

1979 Urban Genesis in Mainland South East Asia. In *Early
 South East Asia*, edited by R. B. Smith and W. Watson.
 London: Oxford University Press, 288-303.

WOLTERS, O. W.

1961 Srivijayan Expansion in the Seventh Century. *Artibus
 Asiae* 24(3-4):417-18.

1979 Khmer 'Hinduism' in the seventh century. In *Early
 South East Asia*, edited by R. B. Smith and W. Watson.
 London: Oxford University Press, 427-42.

1982 *History, Culture and Region in Southeast Asian Perspectives.*
 Singapore: Institute of Southeast Asian Studies.

WOODWARD, JR., H. W.

1974 Reviews. *The Journal of the Siam Society* 62 (July 1974):
 317-375.

1983 Interrelations in a Group of South-East Asian
 Sculptures. *Apollo* 118 (261, November 1983): 379-83.

1988 Southeast Asian Traces of Buddist Pilgrims.
 Muse 22:75-91.

ZWALF, W., ED.

1985 *Buddhism: Art and Faith.* London: British Museum.

GLOSSARY

abbayamudra: SEE reassurance, gesture of.

Amitabha: Buddha of Infinite Life or Light.

Avalokiteshvara: Bodhisattva of compassion.

benediction, gesture of (*varadamudra*): Gesture in which the hand is lowered, palm out.

bhumisparshamudra: SEE earth-touching gesture.

bodhisattva: A compassionate being who forswears nirvana in order to help others attain enlightenment; in some cases, a Buddha-to-be.

dhyanamudra: SEE meditation, gesture of.

diamond posture (*vajrasana*): sitting posture in which both legs are crossed, with each foot resting on the opposite thigh.

earth-touching gesture (*bhumisparshamudra*): Gesture in which the right hand, palm in, reaches to the ground.

elucidation, gesture of (*vitarkamudra*): Gesture in which the hand is raised, with the thumb and forefinger touching.

"European" posture (*pralambitapadasana*): Sitting posture in which both legs are extended and/or pendant.

heroic posture (*virasana*): Sitting posture in which the legs are folded and one foot is placed on the opposite thigh.

maharajalilasana: SEE royal ease, posture of.

Mahayana: Later branch of Buddhism, apt to stress the concept of salvation through the efforts of others, such as bodhisattvas (also known as Sanskrit Buddhism).

Maitreya: Buddha of the future age; a bodhisattva during the present age.

mandala: Cosmic diagram, often used as the focus of meditation in both Buddhism and Hinduism.

meditation, gesture of (*dhyanamudra*): Gesture in which the hands rest on the lap, one on top of the other, palms up.

Prajnaparamita: Buddhist goddess of the perfection of wisdom.

pralambitapadasana: SEE "European" posture.

reassurance, gesture of (*abbayamudra*): Gesture in which the hand is raised, palm out.

royal ease, posture of (*maharajalilasana*): sitting posture in which one leg is folded and the foot of the other rests on the ground.

Shakyamuni: The founder of the Buddhist religion and the Buddha of the present age.

Shiva: Hindu god of destruction and regeneration of the universe.

stupa: Mound or tower used to mark the location of relics of the Buddha or of a Buddhist spiritual leader.

Tara: Buddhist goddess of compassion.

Theravada: Term used for the older, more austere branch of Buddhism (sometimes called Hinayana or Pali Buddhism).

ushnisha: Cranial protuberance, symbolic of supernal wisdom, characteristic of Buddhas.

Vajrapani: Buddhist deity, the thunderbolt-bearer.

vajrasana: SEE diamond posture.

varadamudra: SEE benediction, gesture of.

virasana: SEE heroic posture.

Vishnu: Hindu god, preserver of the universe.

vitarkamudra: SEE elucidation, gesture of.

ROMANIZED TERMS

Throughout the text, simplified spellings in the Roman alphabet have been used for words from languages originally written in other scripts. In this table are found more linguistically accurate transcriptions.

SIMPLIFIED VERSION	WITH DIACRITICALS
abhayamudra	abhayamudrā
Amaravati	Amarāvāti
Amitabha	Amitābha
Amitayurbuddhanusmrti sutra	Amitāyurbuddhānusmṛti sūtra
Andhra	Āndhra
Anuradhapura	Anurādhapura
Ashoka	Aśoka
ashtamahabodhisattva	aṣṭamahābodhisattva
Ashtamandalaka sutra	Aṣṭamaṇḍalaka sūtra
Atisha	Atīśa
Avalokiteshvara	Avalokiteśvara
Avatamsaka sutra	Avataṃsaka sūtra
bhumi	bhūmi
bhumisparshamudra	bhumisparśamudrā
Borobudur	Boroḍuḍur
Buddhanusmrtisamadhisagara sutra	Buddhānusmṛtisamādhisāgara sūtra
Chalukya	Cāḷukya
Dashabhumika sutra	Daśabhūmika sūtra
dhyanamudra	dhyānamudrā
Divyavadana	Divyāvadāna
Diyeng	Diēng
Dvaravati	Dvāravatī
Gandavyuha	Gaṇḍavyūha
Gunavarman	Guṇavarman
Ishanapura	Īśānapura
Kashyapa	Kāśyapa
Kauthara	Kauthāra
Kobo Daishi	Kōbō Daishi
Kukai	Kūkai
Kukkutapada	Kukkutapāda
Kumarajiva	Kumārajīva
Kushana	Kuṣāṇa

Kutagara sutra	Kūṭāgāra sūtra
Lakshmindralokeshvara	Lakṣmīndralokeśvara
Lokottaravadin	Lokottaravādin
Mahamuni	Mahāmuni
maharajalilasana	mahārājalīlāsana
Maharashtra	Mahārāṣtra
Mahasamghika	Mahāsāṃghika
Mahasiddha	Mahāsiddha
Mahavastu	Mahāvastu
Mahaviharavasin	Mahāvihāravāsin
Mahayana	Mahāyāna
mandala	maṇḍala
nagakeshara	nāgakeśara
nirvana	nirvāṇa
Pali	Pāli
Panduranga	Pāṇḍuraṅga
Prajnaparamita	Prajñāpāramitā
pralambitapadasana	pralambitapādāsana
Punyodaya	Puṇyodaya
Rashtrakuta	Rāṣtrakūṭa
Sadhanamala	Sādhanamala
Shailendra	Śailendra
Shakyamuni	Śākyamuni
Shiva	Śiva
Shri Canasa	Śrī Canāsa
Shrikshetra	Śrīkṣetra
Shrivijaya	Śrīvijaya
stupa	stūpa
Tara	Tārā
Tushita	Tuṣita
ushnisha	uṣṇīsa
Vajrapani	Vajrapāṇi
vajrasana	vajrāsana
Vajrayana	Vajrayāna
Vakataka	Vākāṭaka
varadamudra	varadamudrā
Vidyadharani	Vidyādharaṇī
Vijayavirya	Vijayavīrya
virasana	virāsāna
Vishnu	Viṣṇu
vitarkamudra	vitarkamudrā

WORKS IN THE EXHIBITION

PRAKHON CHAI AND RELATED SITES

Maitreya. pp. 1, 4, 5, 8 – 9, 64, 66
Thailand, excavated at Prakhon Chai; 8th century
Bronze with inlays of silver and black stone
38 in (96.5 cm)
The Asia Society, The Mr. and Mrs. John D. Rockefeller
3rd Collection, 1979.63

Maitreya. p. 34
Thailand; early 8th century
Silver with inlaid eyes
18 ¼ in (46.4 cm)
Robert Hatfield Ellsworth Private Collection

Maitreya. p. 35
Thailand, excavated at Ban Fai (Lam Plai Mat); 8th century
Bronze with inlaid eyes
27 ½ in (69.9 cm)
National Museum, Bangkok

Avalokiteshvara. p. 38
Thailand, excavated at Prakhon Chai; 7th century
Bronze with inlaid eyes
27 ½ in (69.9 cm)
Asian Art Museum of San Francisco, The Avery Brundage
Collection, B65 B57

Avalokiteshvara. p. 39
Thailand, attributed to Prakhon Chai; late 8th – early 9th century
Bronze
32 in (81.3 cm)
Private collection

Avalokiteshvara. p. 37
Thailand; 8th century
Bronze
21 in (53.3 cm)
Denver Art Museum, purchased with contributions from the
Marion Grace Hendrie Endowment Trust, Mr. and Mrs.
Frederick R. Mayer, Barbara Mack McKay, and with additional
donations from Jane B. McCotter, Edith M. Daley, JRH-I 1982
Charitable Trust, Mr. and Mrs. Bowers Holt, Tweet Kimball,
Walabi's, Dr. and Mrs. Marshall A. Freedman, Bombay Club
Benefit, Lisle L. Bradley, James Mills, Mr. and Mrs. Yale H.
Lewis, Margaret F. Polak, Dr. and Mrs. John A. Fleming,
Elizabeth B. Labrot, Asian Art Association, and gifts to the
Pan-Asian Collection Fund, 1983.14

Head of a Bodhisattva. p. 36
Thailand, excavated at Ban Tanot; 8th century
Bronze
27 ¼ in (69.2 cm)
National Museum, Bangkok

Avalokiteshvara. p. 44
Thailand; 8th century
Bronze
14 in (35.6 cm)
Robert Hatfield Ellsworth Private Collection

Buddha. p. 40
Thailand, excavated at Tambon Thaisamakhi (Lam Plai Mat);
8th century
Stone
47 ¼ in (120.0 cm)
National Museum, Bangkok

THE BUDDHIST ART AND CULTURE OF MAINLAND SOUTHEAST ASIA

PRE-ANGKOR AND ANGKOR TRADITIONS

Bodhisattva. p. 89
Cambodia; 7th century
Bronze
11 ¼ in (28.5 cm)
Doris Wiener collection

Avalokiteshvara. p. 59
Southeast Asia; 8th century
Bronze
4 ⅝ in (11.7 cm)
The Asia Society, The Mr. and Mrs. John D. Rockefeller
3rd Collection, 1979.81

Maitreya. p. 67
Thailand, from vicinity of Chaiyafum; 8th century
Bronze
7 ¾ in (19.7 cm)
Philadelphia Museum of Art, Given by
R. Hatfield Ellsworth, 1965-133-001

Avalokiteshvara. p. 68
Thailand; 8th century
Bronze
8 ⅝ in (22.0 cm)
Mr. and Mrs. Robert M. Beningson collection

Shakyamuni. p. 60
Cambodia; 7th century
Sandstone
19 ¼ in (49.0 cm)
Doris Wiener collection

Head of a Buddha. p. 52
Cambodia, style of Angkor Borei; 6th century
Sandstone
23 in (58.4 cm)
Private collection

Buddha. p. 53
Cambodia, Angkor Borei; 7th century
Sandstone
25 in (63.5 cm)
D. A. Latchford collection

THE ART OF DVARAVATI

Buddha. p. 33
Thailand; 8th century
Bronze
20 ½ in (52.0 cm)
Alsdorf Collection, Chicago

Buddha. p. 31
Thailand; 8th century
Limestone
36 ½ in (92.7 cm)
The Asia Society, The Mr. and Mrs. John D. Rockefeller
3rd Collection, 1979.75

Buddha. p. 32
Thailand; 8th century
Bronze
About 18 in (45.7 cm)
Private collection

Buddha. p. 30
Thailand; 8th century
Bronze
About 28 in (71.1 cm)
Private collection

Buddha. p. 29
Thailand, found near Phong Tuk; 8th century
Bronze
14 ¼ in (36.2 cm)
Robert Hatfield Ellsworth Private Collection

Maitreya. p. 69
Thailand; 7th century
Bronze
8 ½ in (21.6 cm)
The Brooklyn Museum, Gift of Mr. and Mrs. Edward
Greenberg, 86.259.2

THE KINGDOM OF SHRIVIJAYA

Avalokiteshvara. p. 79
Thailand, found at Chaiya, Surat Thani; 7th century
Stone
45 ¼ in (115.0 cm)
National Museum, Bangkok

Bodhisattva. p. 94
Thailand; late 8th century
Bronze
6 in (15.2 cm)
Private collection

Avalokiteshvara. p. 43
Thailand; 9th century
Bronze
9 ¼ in (23.5 cm)
Mr. and Mrs. Gilbert H. Kinney collection

Avalokiteshvara. p. 73
Thailand; 9th century
Bronze
8 ½ in (21.5 cm)
National Museum, Bangkok

Maitreya. p. 81
Thailand; 7th century
Bronze
10 ¼ in (26.0 cm)
Robert Kipniss collection

Vairocana with Attendants. pp. 16, 18
Thailand; late 8th century
Bronze
8 in (20.0 cm)
National Museum, Bangkok

Bodhisattva. p. 49
Indonesia, Sumatra; late 7th – early 8th century
Bronze
8 ¼ in (21.0 cm)
Robert Kipniss collection

Buddha. p. 41
Indonesia, Sumatra, excavated at Palembang; 8th century
Bronze
13 in (33.0 cm)
Nancy Wiener collection

INTERCONNECTIONS:
BUDDHIST ART FROM INDIA,
SRI LANKA, AND JAVA

Shakyamuni. p. 20
India; late 6th century
Bronze
19 ⅜ in (49.2 cm)
The Asia Society, The Mr. and Mrs. John D. Rockefeller
3rd Collection, 1979.9

Avalokiteshvara. p. 22
India, Bihar, Kurkihar; about 900
Copper
6 ¾ in (17.1 cm)
Los Angeles County Museum of Art, from the Nasli and Alice
Heeramaneck Collection, Museum Associates Purchase, M81.8.3

Avalokiteshvara. p. 50
Sri Lanka; 7th – 8th century
Bronze
8 ¾ in (22.2 cm)
The Asia Society, The Mr. and Mrs. John D. Rockefeller
3rd Collection, 1979.41

Buddha. p. 21
Sri Lanka; 8th century
Bronze
6 in (15.2 cm)
D. A. Latchford collection

Buddhist Goddess. p. 54
Indonesia, Java; Central Javanese period, 8th century
Bronze
6 ¼ in (15.9 cm)
The Asia Society, The Mr. and Mrs. John D. Rockefeller
3rd Collection, 1979.84

Avalokiteshvara. p. 82
Indonesia, Java; Central Javanese period, 9th century
Bronze
8 in (20.3 cm)
Private collection

Jambhala. p. 27
Indonesia, Java; 9th century
Bronze
5 ½ in (14.0 cm)
Mr. and Mrs. Gilbert H. Kinney collection

Dancing Divinity. p. 47
Indonesia, Java; 9th century
Stone
30 ½ in (76.25 cm)
Susan L. Beningson collection

Vajrahunkara. (not illustrated)
Indonesia, Java; 10th-11th century
Bronze
3 ⅝ in (9.2 cm)
Private collection

IMAGES OF MAITREYA FROM SOUTH AND SOUTHEAST ASIA

Bodhisattva, probably Maitreya. p. 76
India, Kashmir; about 400
Bronze
10 ½ in (26.7 cm)
Los Angeles County Museum of Art, from the Nasli and Alice
Heeramaneck Collection, Museum Associates Purchase, M69.15.2

Maitreya. p. 74
India, possibly Bihar; about 12th century
Bronze
7 ¼ in (18.4 cm)
Mr. and Mrs. John Gilmore Ford collection

Buddha Maitreya. p. 88
Nepal; 12th century
Bronze
9 in (23.0 cm)
The Asia Society, The Mr. and Mrs. John D. Rockefeller
3rd Collection, 1983.1

Buddha Maitreya. p. 90
Tibet; 13th century
Gilt bronze
6 ¾ in (17.1 cm)
Zimmerman Family collection

Maitreya. p. 77
Nepal; 11th century
Bronze
17 ¼ in (43.8 cm)
Los Angeles County Museum of Art, Gift of Mr. and Mrs.
J. J. Klejman, M70.18

Maitreya. p. 78
Pakistan, Gilgit or Swat; 9th century
Brass with cold-gold painted face and silver or electrum eyes
10 in (25.1 cm)
The Nelson-Atkins Museum of Art, Kansas City, Missouri,
Purchase, Nelson Trust, 66-22

Maitreya. p. 45
Thailand, excavated at Ban Lan Khwai; 8th century
Bronze
6 ⅜ in (16.2 cm)
National Museum, Bangkok

Maitreya. p. 12
Thailand, excavated at Prakhon Chai; late 8th century
Bronze
48 ¼ in (122.5 cm)
Kimbell Art Museum, Fort Worth, Texas AP 65.1

LENDERS TO THE EXHIBITION

Alsdorf Collection, Chicago

The Asia Society

Asian Art Museum of San Francisco

Mr. and Mrs. Robert M. Beningson

Susan L. Beningson

The Brooklyn Museum

Denver Art Museum

Robert Hatfield Ellsworth Private Collection

Mr. and Mrs. John Gilmore Ford

Kimbell Art Museum, Fort Worth, Texas

Mr. and Mrs. Gilbert H. Kinney

Robert Kipniss

D. A. Latchford

Los Angeles County Museum of Art

National Museum, Bangkok

The Nelson-Atkins Museum of Art, Kansas City, Missouri

Philadelphia Museum of Art

Doris Wiener

Nancy Wiener

Zimmerman Family

Two anonymous collectors

PHOTOGRAPH CREDITS

All photographs courtesy of the owner unless otherwise noted

Courtesy of Nandana Chutiwongs, pp. 24, 25, 57

Lynton Gardiner, pp. 1, 4, 5, 8–9, 20, 27, 29, 31, 34, 43, 44, 50, 54, 59, 64, 90; cover

Justin Kerr, p. 68

Blakeslee Lane, p. 74

Erik Landsberg, pp. 39, 52, 94

C. Nardiello, p. 88

Courtesy of Spink & Son Ltd., p. 82

Roman Szechter, p. 66

Ellen Page Wilson, p. 60